CW00484755

CREATIVITY
— and its —
CONTEXTS

CREATIVITY

—— and its ——

CONTEXTS

Chris Morash (ed.)

THE LILLIPUT PRESS
MCMXCV

Copyright © 1995 individual contributors.

All rights reserved. No part of this publication
may be reproduced in any form or by any means
without the prior permission of the publisher.

First published in 1995 by
THE LILLIPUT PRESS LTD
4 Rosemount Terrace, Arbour Hill,
Dublin 7, Ireland.

A CIP record for this
title is available from
The British Library.

ISBN 1 874675 67 8

Acknowledgments
The Lilliput Press receives financial assistance
from An Chomairle Ealaíon/The Arts Council

Cover design and layout by
mermaid:turbulence
Set in 11 on 15 Garamond[3]
Printed in England by
Cambridge University Press

CONTENTS

PREFACE

In 1912 W.B. Yeats provided an introduction to a selection of
English prose translations of the Bengali poet Rabindranath
Tagore. He wrote, in this notably enthusiastic effort to bring
Tagore's work to the attention of the English-speaking world, of
how difficult it was to establish the poet's context given the
paucity of information about him available in the West. He con-
fessed how he had remarked to a Bengali doctor of his acquain-
tance, 'though [they] have stirred my blood as nothing has for
years, I shall not know anything of his life, and the movements of
thought that have made them possible, if some Indian traveller
will not tell me'. He was, it seems, at such a loss that he told his
Indian friend, 'for all I know, so abundant and simple is this
poetry, the new Renaissance has been born in your country and I
shall never know of it except by hearsay'. From his acquaintance
and from other Indians who came to see Yeats, the poet learnt that
Tagore indeed was venerated in his own land as the greatest poet
of his age, that 'we call this the epoch of Rabindranath'. He
learnt, too, of the Tagore family, and how 'for generations great

men have come out of its cradles'. The dynastic context of Tagore's achievement, as reported to him, was especially gratifying to the Yeats who in 1912 was beginning to develop his own theories about the significance of familial tradition as the creative context in which art can grow and flourish. He was delighted to learn that 'When Rabindranath was a boy he had all around him in his home literature and music', and he makes of his introduction a celebration of the gentle, spiritual civilization from which Tagore emerged as if to censure the gross materialism and violence of Western society:

We write long books where no page perhaps has any quality to make writing a pleasure, being confident in some general design, just as we fight and make money and fill our heads with politics—all dull things in the doing—while Mr Tagore, like the Indian civilization itself, has been content to discover the soul and surrender himself to its spontaneity.

Yeats's introduction to Tagore's poems is a testament to his belief that context is central to creativity and to his conviction that a family in which an artistic tradition finds sustained expression is one of the most likely sources of that creativity. It was highly appropriate therefore that one of the four main lectures delivered in July 1992 at the IASAIL conference on 'Creativity and its Contexts' in Trinity College, Dublin (as part of the college's Quatercentenary) should have dealt with two remarkable Bengali artists who found their inspiration in familial contexts: Tagore himself, and the film director Satyajit Ray. What emerged from Anita Desai's thoughtful account of both was how remarkably similar were the concerns and situation of Tagore in his Bengali context of family and nation to those of the Yeats family itself in Victorian and early twentieth-century Irish society. And Ray's family and experience was not dissimilar to that of Tagore, sharing too with Yeats a background that combined rural and urban experience and cultural nationalist ideals with financial insecurity.

PREFACE

Yeats's introduction to Tagore's *Gitanjali (Song Offerings)* is a
Yeatsian panegyric to the idea of the family as cultural resource,
to the Confucian ideal that one noble family can elevate a nation
into virtue. For the poet, the family must be the site of an unbro-
ken civilization. 'In the east', he tells one of his Indian informants,
'you know how to keep a family illustrious'. Ironically, some of
Tagore's works and Ray's cinematic versions of them had not been
eulogies of stable family life but explorations of the pain and con-
flict that families must endure in highly traditional societies
when experience challenges customary expectation. It was in such
a context that Tagore had offended against the values of Bengali
society in his fiction, in just the way Synge had managed to
affront pious Irish opinion in his plays when he dramatized sexual
frustration on the stage of the Abbey theatre. Tagore and Ray,
who filmed Tagore's novel of sexual jealousy *The Broken Nest,* had
in fact endured obloquy in their own country akin to that Yeats
and Synge had experienced in Ireland when their theatre dared to
challenge a conventional middle-class image of Irish womanhood.
In a further irony, Yeats was turning in 1912 to a highly idealized
version of Tagore's family tradition in distaste for the kinds of bat-
tles he had been forced to fight in a society that had hated *The
Playboy of the Western World.* What Desai's lecture further lets us
see was that it is not necessarily the idyllic, dynastic calm of an
'unbroken civilization' that is the cradle of genius, as Yeats at this
stage in his career imagined; rather it is the complexity and chal-
lenge of difficult, mutable experience.

This latter consciousness was the main burden of the lectures
delivered at the conference by three Irish writers who gave the
other plenary addresses collected here. Two poets and a dramatist,
renowned not only for their creative work but for the acuity of
their critical awareness, in their varying ways allowed us to under-
stand how the context in which art can thrive is often compact of

difficulty, challenge and even the most desolate pain.

Eavan Boland, in her own cogently argued and heartfelt contribution, addressed the difficulty which the female poet in Ireland experiences in attempting to site her work in a tradition that has reified woman as Language, Muse and Nation. For Boland, a motor of creativity has been found in the pressingly urgent need for female experience to be inscribed fully in the Irish experience and not as an adjunct to it or as available metaphor for its expression. She concludes, 'The poetry being written by women in Ireland is Irish poetry. It stands in the mainstream of that valuable tradition; and like all such entries into a tradition, it re-orders what is there'.

This formulation suggests in its self-conscious allusion to a famous essay by T.S. Eliot that Boland was arriving at a view on tradition and the individual female talent. What gave her lecture its moral authority, however, was the sense it stimulated that she was speaking not only for women poets as individuals but for a generation of women writers for whom she sought to serve as articulate public representative. A sense of civic, collective duty discharged gave to her lecture a tone of polemical necessity, an edge of challenging, outspoken commitment.

A similar note was struck in poet Michael Longley's passionately practical self-portrait of the artist as administrator in a grievously divided society. His account of bureaucratic wars in the Arts Council of Northern Ireland and the slow attrition that official life works on the spirit of innovation was chronicled with wry assurance and not a little suppressed rage. What shone through was generous admiration for loyal colleagues and for work well-done in the teeth of institutional entropy and downright bad faith. It was clear from his spirited contribution to the conference that government policy in general, and specific decisions about personnel, can in a modern society have profound impact on the

artistic health of a community. Creative context, it was evident, depends not only on men and women as individuals but on enlightened, truly informed officialdom which will 'champion the individual creator and indigenous talent'.

Throughout Michael Longley's lecture, as he spoke with genuine diffidence about his own achievements, one was aware that the backdrop to the work he had done in more than two decades of conscientious, brave service was not simply a divided society but one in which those divisions, about which he spoke so eloquently, were the cause of much terrible suffering and recurrent danger. One was conscious that the writer and artist have no immunity to the pain of atrocious realities which their work must address if it is to justify itself as a mode of human authenticity.

It was perhaps dramatist Frank Mc Guinness' mesmeric performance in his address in which he took us to the anguished heart of Wilde's *De Profundis* that most compellingly brought home to the delegates at IASAIL 92 how art can emerge from the most estranging contexts, from the prison of emotional pain for which Reading Gaol in Wilde's work served only as a metaphor. In the context of the conference's deliberations, what Mc Guinness' charged meditation suggested was that while context is necessary to creativity, it is nothing without the miracle of the individual creative impulse. He quoted Wilde himself ajudging in *The Soul of Man under Socialism* that a work of art is 'the unique result of a unique experiment'. In a period of four days, when over two hundred and sixty delegates from many different countries of the world had the opportunity to select among over one hundred papers on the theme of 'Creativity and its Context', Wilde's words and experience, so movingly brought to our attention in Mc Guinness' lecture, were a salutary and apposite reminder of the irreducible in a work of art, of what in creativity cannot simply be ascribed to context.

PREFACE

It is through the good offices of The Lilliput Press, and with the financial support of Trinity College, that we are able to publish these lectures (ably edited by Dr Christopher Morash), so leaving members of IASAIL with a permanent record of the four writers' memorable contributions to IASAIL 92.

TERENCE BROWN
NICHOLAS GRENE

BLACKTHORN AND BONSAI
OR, A LITTLE BRIEF AUTHORITY

MICHAEL LONGLEY

... man, proud man, dressed in a little brief authority ...

I am a founder-member of the Cultural Traditions Group which [I]
came together nearly four years ago with the aim of encouraging
acceptance and understanding of cultural diversity in Northern
Ireland. We went public the following year by holding a confer-
ence called 'Varieties of Irishness'. The distinguished Irish histo-
rian Roy Foster gave the keynote lecture at the end of which he
referred to a poetry reading tour undertaken by John Hewitt and
John Montague away back in November 1970. Foster talked of
Hewitt, '... who articulated that quintessential combination of
Protestant scepticism and commitment, linked with a sense of
place that was absolutely Irish'. He went on to say that 'Hewitt's
poetry tour with John Montague in 1970, 'The Planter and the
Gael', was a landmark affirmation of creative cultural diversity'.
'The Planter and the Gael' was the first event which I organized
for the Arts Council of Northern Ireland. In the booklet which
accompanied the tour I wrote:

[3]

In the selection of his poems each poet explores his experience of Ulster, the background in which he grew up and the tradition which has shaped his work. ... The two bodies of work complement each other and provide illuminating insight into the cultural complexities of the Province.

In this talk I shall tell the story of my twenty-one years as an arts administrator and bureaucrat—from 1970 and 'The Planter and the Gael' to the late eighties/early nineties and my involvement with the Cultural Traditions movement—two decades in which momentous and often terrible things have happened in Ulster, in Ireland. As I picked my way through the mine-field, I operated intuitively rather than intellectually. So I shall be talking about what happened. Events brought my beliefs to the surface, and confirmed or changed my ideas.

It was often a struggle to secure modest budgets for disciplines which were not represented by powerful lobbies, a struggle against vested interests. The 'blackthorn' of my title represents indigenous talent (the writers and traditional musicians who— along with some painters—are the main reason why we enjoy a cultural reputation abroad. They are also of course sources of energy at home). The 'bonsai' stands for money-devouring activities such as orchestral music and opera which in their Irish manifestations make comparatively little impact on the world stage. The analogy crumbles a bit when we realize that the Japanese, unlike our own cultural panjandrums, intend their little trees to remain little. I was never opposed to orchestral music or opera. How could anyone be? My criticisms were directed at the quality of decision-making. I argued for a sense of proportion and fair play.

At a joint meeting of the two Irish Arts Councils at the Ulster Folk Museum in 1983 I imagined the ghosts of present administrators being interrogated by their great-great-grandchildren: 'Well, thank you for buttressing the reputations of Mozart and

Beethoven, but what did you do to promote the great singing of Eddie Butcher and Sarah Makem, the virtuoso fiddling of Johnny Doherty? In the 1980s there was an important dramatic movement in Belfast that produced many interesting urban working class plays. What did you do to make it possible for those talents to work in and illuminate the back streets from which they emerged?'

I went on to suggest that the imbalance between support for the performing arts and support for the creators pointed to other imbalances. In the sphere of arts administration there was a danger of administration outweighing the arts. For instance, every year the Council organizes a Regional Conference for local arts committee members and town councillors. Why, I asked, should there not take place every five years or so a conference for artists? There was also a class imbalance. In relation to the size of its middle class Belfast has the largest working class in Europe. The price alone of many Council events puts them out of reach. The people ideally suited to bring the arts to what we termed 'deprived areas' were the local artists. These ideas suggested a third imbalance—that between 'mail-order culture' and the nurturing of indigenous talent. There were, for example, financial reasons why the Grand Opera House in Belfast should import tinsel; but it seemed shortsighted to import so much tinsel when we were sitting on a goldmine which was still relatively underexploited. Ulster no longer merited the playwright Sam Thompson's dismissal—'a cultural Siberia'. In as much as creative imaginations could now get by there, the Province had become less provincial. Releasing original talents into the community should be the Council's profoundest involvement.

Over the years I kept asking two simple questions. How much of our programme will posterity thank us for? How much of what we are doing differentiates us from Bolton or Woverhampton? In

short, 'where there is not vision, the people perish.' I was pleased
to find a spiritual ally in the great geographer Estyn Evans who
had written in *Ulster: The Common Ground*: 'Certain cultural traits
persist and can be related in one way or another to a pastoral her-
itage.' He went on to suggest that, 'in the arts, for instance, the
natural thing for the Irish is not the communal effort of expensive
orchestral music but the lone fiddler'.

My job was often fulfilling, and sometimes funny. 'The Planter
and the Gael' poetry-reading tour provided me with a lasting
image. My old friend and colleague the late Paul Clarke was then
the Council's Promotions Officer. At the last moment he decided
on some nifty presentational improvements—among them
throne-like seats for our two bards. The varnish had not dried out
in time for the opening night so that when the always dignified
John Hewitt rose to recite his first poem, there was a loud ripping
noise. In the Arts Council I occasionally sensed a similar back-
wards tug as I prepared to rise.

There are five Arts Councils on the archipelago: one in Belfast,
one in Dublin; and, across the water, the Scottish and Welsh Arts
Councils which are funded by the fifth and largest body, the Arts
Council of Great Britain. This began its days after the last war as
a morale-booster with the unbalanced title of Council for the
Encouragement of Music and the Arts (CEMA). A Northern Irish
model followed several years later. It was beginning to make up
for lost time, when the eruption of civic violence in the late six-
ties and early seventies caused what Kenneth Jamison, the Coun-
cil's Director for twenty-five years, has rather euphemistically
called 'a protracted spasm of social paralysis'. From this paralysis
there are—as audience statistics demonstrate—remissions. The
Council is funded by the Northern Ireland Office through the
Department of Education, and the sum allocated to it this year is
in the region of £6,000,000. Its objects are to improve the prac-

tice and appreciation of the arts and to increase their accessibility to the people of Northern Ireland.

I joined the Council in 1970 as a temporary Exhibitions Officer. [II] (I had been reviewing local art exhibitions for *The Irish Times*). A few years before my arrival the Board had decreed that because it was practised by amateurs, literature did not come within its remit (so much for part-time scribblers like T.S. Eliot, bank clerk and publisher, and for those in insurance or medicine like Wallace Stevens and William Carlos Williams!). In my first year, as well as hanging pictures and lecturing about them, I edited *Causeway*, a comprehensive survey of the arts in Ulster, and an anthology of poetry written by children called *Under the Moon, Over the Stars*; and I initiated the programme for literature with a budget of £3000. Those earliest grants included £143 for the *Honest Ulsterman* magazine; £50 each for poetry pamphlets by Frank Ormsby and Ciaran Carson; £150 for *Soundings*, a magazine edited by Seamus Heaney; £1000 for the Blackstaff Press and six titles by, among others, Sam Hanna Bell, James Simmons and Stewart Parker; and £800 for the Dublin publishing house of Gill and Macmillan to bring out pioneering critical studies by two academics from Northern Ireland who were already registering the new creative buzz: *Forces and Themes in Ulster Fiction* by John Wilson Foster and *Northern Voices: Poets from Ulster* by Terence Brown.

Despite my ignorance, I initiated in 1972–3, with a small but not ineffectual budget, a programme for what we eventually christened the traditional arts. One of the first people I contacted was Estyn Evans. I invited him to select the images and prepare a commentary for a book of R.J. Welch's photographs of Ireland and Irish life at the end of the last century. Published some time later by Blackstaff Press, *Ireland's Eye* heralded the revival of inter-

est in our pioneer photographers as readily assimilable inter-
preters of our common past. In his introduction Evans writes
about the Belfast Naturalists' Field Club of which Welch was a
leading member: 'The Field Club was non-sectarian, and it seems
to have attracted men of goodwill who deplored the political and
sectarian fragmentation that disfigured the face of Belfast.'

In 1972 John Hewitt retired from his job as Director of the
Herbert Art Gallery and Museum in Coventry, and returned after
a fifteen-year exile to Belfast and his remarkably productive
Indian summer. In his introduction to *Ireland's Eye* Estyn Evans
speculates:

It would be interesting to trace the relationship between the field-club move-
ment and another phenomenon which was more directly a cultural by-product
of the textile industry in Ulster. Throughout the Province, as John Hewitt has
shown in his book *Rhyming Weavers*, the weaving areas produced many poets,
especially in the first half of the nineteenth century, some of them showing con-
siderable talent.

Like a kestrel hovering above a tiny field, Evans wonders about
'the links between the work involved in handling different kinds
of natural fibres and regional patterns of cultural expression'.

The mutual awareness of Evans and Hewitt dated from the
1940s when the philosophy of regionalism had been vigorously
debated. They inspired my thinking, and gave me a sense of con-
tinuity. Thanks to them, the programmes for literature and the
traditional arts began to overlap and provide shelter for modest
but timely explorations. Hewitt had already written my script:

Out of that loyalty to our own place, rooted in honest history, in familiar folk-
ways and knowledge, phrased in our own dialect, there should emerge a culture
and an attitude individual and distinctive, a fine contribution to the European
inheritance and no mere echo of the thought and imagination of another people
or another land.

The first traditional arts committee included real experts like

Sean Ó Baoill the collector of songs; the singer David Hammond; Brendan Adams from the Folk Museum who pored over dialect maps during meetings; Maurice Hayes who much later was to become our Ombudsman and the Chairman of the Cultural Traditions Group. On the literature committee John Hewitt spoke infrequently but always with such weight few would contradict him! My education was proceeding apace.

Hierarchies are obsessed with titles. For my last nine years I was designated the Combined Arts Director. Although I oversaw Traditional Arts, Young Arts and Community Arts, colleagues now ran these programmes, and my own speciality remained Literature. The central plank of this programme is of course publication, the printed word. Much of any arts organization's activity resembles a tidal wave which leaves behind little or no residue. One of the pleasures of a literary post is the accumulation over the years of desirable objects with an indefinite shelf-life. The objectives define themselves: to provide publishing outlets for local authors; to facilitate the continuing existence of local publishing houses; to make available to the local community and to readers elsewhere the best contemporary Ulster writing; to keep in print distinguished literature from the recent past; and to represent our generation to itself, the world at large, and to posterity.

Magazines and journals which publish Irish writers and reflect the cultural life of the Province (and island) are also helped financially. The idea is to provide an outlet for young up-and-coming authors as well as established talents; to keep the bibliographical tally up to date; and to encourage good criticism and a lively critical climate. T.S. Eliot remarked that the cultural health of a community could be judged by the liveliness or otherwise of its magazine tradition. I find some reassurance in the continuing vigour of established magazines and the emergence of new ones. An old warhorse like the *Honest Ulsterman* is known far beyond Northern

Ireland. Newcomers like *Rhinoceros* provide an alternative platform, especially for young mavericks. Local writers and writing are welcomed by the political journal *Fortnight*, the back part—the cultural pages—of which I subsidized, despite official pressures.

It is also a good idea to introduce writers to the public, to provide opportunities for the community to meet and listen to 'living writers'. An author's physical voice does influence the way he or she writes. Despite Caxton and Derrida, literature still takes shape in the mouth and finds its resting place in the ear. Visitors such as Robert Lowell, Hugh MacDiarmid, Angela Carter, Miroslav Holub, Liz Lochhead, Ian McEwan, Marin Sorescu, Tony Harrison, Joseph Brodsky have helped us to avoid literary inbreeding and cultural insularity. Most of the generals and field marshals of what Patrick Kavanagh humorously referred to as Ireland's 'standing army' of writers have performed for us. 'The Planter and the Gael' wasn't the only poetry-reading tour. 'Out of the Blue' featured James Simmons and Paul Muldoon; 'In their Element', Derek Mahon and Seamus Heaney.

I didn't see such tours as a priority, and preferred to use limited funds to engage the community in more lasting ways. Two writer-in-residence posts at Queen's University and the University of Ulster have allowed the embryo writer to discuss his or her work with established practitioners, who, in turn, have enjoyed more time in which to create. Recently the Council established a third post—that of Writer-in-Residence in the Irish language—shared between the two universities. So far as I know, there is no equivalent position elsewhere on the archipelago.

I often expressed the hope that the principles of these residencies might be extended into the community. This dream came true towards the end of my bureaucratic career when four young artists—a novelist, a painter, a traditional flute-player and a photographer—were employed by the Council to work through

schools and colleges, community centres, museums, libraries, local history groups and so on. I gave this scheme the extrovert title *Outlook*, and in the explanatory brochure wrote: 'The Arts Council believes that the regular interaction between artist and community will provide points of growth, new sources of creative energy, opportunities for communal self-examination, self-definition and self-expression.'

This rubric and the three snatches of poetry which I slipped into the brochure suggest not only what I hoped the literature and traditional arts programmes might achieve, but also obstacles and disappointments. The first snippet comes from Louis MacNeice's 'Autumn Journal'—Canto XVI, which is about Ireland:

> ... one feels that here at least one can
> Do local work which is not at the world's mercy
> And that on this tiny stage with luck a man
> Might see the end of one particular action

The second is the ending of Patrick Kavanagh's 'Epic' which measures the Munich crisis against a local territorial squabble:

> I inclined
> To lose my faith in Ballyrush and Gortin
> Till Homer's ghost came whispering to my mind
> He said: I made the Iliad from such
> A local row. Gods make their own importance.

Yeats's 'The Fisherman' provides the third quotation:

> All day I'd looked in the face
> What I had hoped 'twould be
> To write for my own race
> And the reality.

There was a literary tinge and, in retrospect, a symbolic symmetry to the very first grants which I made in 1972 from the new traditional arts budget—one for *Rhyming Weavers*, John Hewitt's

study of the Ulster-Scots vernacular poets of Down and Antrim; and another for a study by Tomás Ó Fiaich—later the Cardinal—of the eighteenth-century South Armagh Gaelic poet Art Mac Cooey. The experience of starting up the literature programme provided templates for the traditional arts. The same principles evolved in much the same way—except that arts administration was to become a much bumpier ride.

I knew very little about Irish music. The 'wise and simple man' who opened doors and helped me to organize the first concerts and tours was a hard-drinking carpenter called Brian O'Donnell, who hailed from Killybegs in Donegal but lived in the Markets area of Belfast. He knew everyone there was to know in the world of Irish music. I revered his deep love of the tradition and learned a lot—even from his erratic, often wild behaviour. We put on our first concert in Belfast's Civic Arts Theatre. This was seen by many as an event of symbolic importance: an organization like the Arts Council was at last taking traditional music seriously! One of the most exciting moments of my life came when I saw the customers queuing around the block to get in. The evening acquired further symbolism. Brian, the soul of the entertainment, got so under the weather that the proprietor of the theatre would not let him in! I had to decide between hearing the concert or attending to Brian's dignity. I chose the latter.

In the early seventies the North was contorted by spiralling sequences of tit-for-tat murders. These were bleak, anxious times to be touring with traditional Irish musicians. But it was crucial to challenge those who would appropriate the music for political ends and those who would excoriate it as alien and even threatening. Nor did we see the point of preaching—playing—to the converted all of the time. There had recently been an IRA atrocity in one of the country towns—mainly Protestant—where we were to play. I took the musicians into the function room of the pub

which had been booked for the night. The owner of the pub said, 'My bar will be blown up unless you begin or end the concert with "The Queen".' I replied, 'I have never heard "The Queen" played on the Irish pipes!' But it was a serious impasse; and I considered calling the whole thing off. The bully boys were out and about; and there was menace in the air. A brain-wave. 'Is there a Jimmy-Stand-type accordeon-player in the town?' I asked, because I had a vague memory that there was such a musician in the vicinity. He might end our concert with some Scottish dance music—and then 'The Queen'. Our musical saviour turned up, and I offered him a fee. The concert proceeded with the audience talking loudly and insultingly all the way through. The gents' toilet was at the side of the small stage. Large tattooed figures lumbered backwards and forwards glaring at the musicians. David Hammond was MC for the night, and he sang every Scottish song in his repertoire. The audience at last quietened for the local box-player who performed several Scottish melodies. By the time he got round to 'The Queen' we had skedaddled. The fingers and thumbs—the lives even—of the musicians had been in danger. This wasn't running away.

On another occasion, at the request of the UDA, we put on a small concert of Irish music in their headquarters in East Belfast. More than a polite interest was shown in the performance, and questions were asked. Our hosts really wanted to find out why one side seemed to have most of the good tunes. We told them about great Protestant interpreters of Irish music like the singers Joe Holmes and Len Graham, the dulcimer-player John Rea of Glenarm. There was more to their tradition than Orange ballads, just as Nationalist ballads were only a small part of Irish music. A witty colleague who was present remarked that the faces of the musicians as they entered the UDA building put him in mind of 'Egyptologists descending into a tomb'! Perhaps there should be

more ventures of this kind which are bold and hare-brained enough to be—literally—disarming. I was later to get involved with the Royal Scottish Pipe Band Association and gave support to their educational programme for over a decade, up to the point where they have now started classes in *Piobaireachd*. Among young pipers it is now fashionable to play Irish music. Last year at the championships in Inverness the top prize was won by an Ulster piper playing an Irish tune on the Scottish pipes!

Because Brian was fond of her, I booked for the second tour Maggie Barry who billed herself as 'The Singing Gypsy Woman'. I ended up loving her vast, untameable personality. Even when Maggie was singing an old chestnut like 'When Irish Eyes are Smiling', there was something authentic about her. In Armagh I realized that the Protestant Primate, George Simms, was sitting in the front row. I said to Maggie, who had been getting raunchier as the week proceeded: 'Maggie, you'll never guess who's in the front row; George Simms the Protestant Primate of All Ireland!' That's all I said. I wasn't going to control her. I couldn't if I tried. Maggie came out and started to tune her banjo. Although she played only the one string, she liked to make a big fuss about tuning it. 'I can't get this damned thing tuned at all', she exclaimed; and then, with an enormous wink in the direction of the Protestant Primate: 'The frets are wet and sticky, but sure isn't that me all over!' Afterwards George Simms came up to me and said, 'I enjoyed the evening so much. Irish music so reminds me of the intricacies of the Book of Kells.'

For me these are parables rather than anecdotes—ways of explaining conversion and spiritual growth. Once I trailed around Donegal with Brian O'Donnell in search of the great Johnny Doherty who, although he was well into his seventies, was still on the road. Even in old age he preferred the life of the itinerant musician. He was a fiddler of consummate artistry, a genius. After

a couple of days we tracked him down to a little pub where he was playing for balls of malt. Most of the small gathering chattered through his soaring music. Brian and I sat down quietly behind him. He must have registered us as an oasis of silence and concentration. When he had finished his first set he turned round slowly and nodded towards us in a dignified fashion. As a bureaucrat I tried to make sure that the least we gave to traditional musicians was an oasis of this kind of respect. As an aspiring artist myself I have dedicated my *Poems 1963–1983* to the memory of Brian O'Donnell.

Ciaran Carson is now the custodian of literature and the traditional arts whose interconnection his own poetry—attentive to the rhythms of musician and seanachie —proclaims. He 'looks into the future through the eyes of the past'. As readers of his brilliant *Pocket Guide to Irish Music* will appreciate, his authoritative voice rings out most clearly in the dialogue between authenticity and renovation. There is an Irish proverb that 'tradition is stronger than learning'. Carson believes that in many cases tradition has to be recovered by learning—by personal contact, by a sensitive use of the comparatively new technology of the video and tape-recorder. He emphasizes the mutual agreement of traditional music-making and its social context. 'Even the most apparently informal session', he says, 'is governed by a complex set of implicit rules in which conversation, singing, playing and dancing are an expression of a wider community.' It has been a relief to hand over to someone so profound and gifted.

Here are two statistics. Over nearly twenty-one years neither the Director nor any of the four Chairmen of the Arts Council attended even one event I had funded or organized in the areas of literature and traditional music. It took me eighteen years to hoist the budget for literature up to £100,000. The budget for dance got there in eighteen months, or thereabouts.

[III] About a year ago I was invited to read my poems to a group of civil servants who were being prepared for top jobs. They had been through several taxing days in what appeared to be a series of initiation rites for the early middle-aged. I was to provide the light relief. Halfway through dessert I looked around at the grey suits and decided that an after-dinner session of undiluted poetry might interfere with digestion. So, since the theme of the course was leadership, I opened up by talking about good leadership, and gave them the best example I could think of from the world of arts.

Lawrence Gilliam was head of the BBC's Features Department. He employed formidable talents like Dylan Thomas, W.R. Rodgers, Henry Reed and Louis MacNeice. When the BBC needs to celebrate some anniversary or other by opening its archive, programmes from the Gilliam stable are among the few that do not date. He knew his own limitations and rejoiced in the strengths of others. Lawrence Gilliam led a brilliant department by *not* leading it. Gifted in his own way, he also had the moral sense and qualities of imagination to realize that he could hardly be Louis MacNeice's leader! No. He was Louis MacNeice's minder, protecting him from bureaucracy, providing him with budgets, sending him to places like India (where MacNeice covered Independence), turning a blind eye to the poet's trips to Ireland which were ostensibly reconnoitres but which almost invariably coincided with rugby internationals at Ravenhill or Lansdowne Road.

In 1945 MacNeice was exhausted. He had written and produced seventy programmes in four years. He came to Ireland to recuperate and to decide whether or not he would return to his job. 'Tell them I'll take three months off—without pay', he wrote to Gilliam. 'Tell them I'm an artist.' Gilliam covered up for him so successfully that MacNeice enjoyed a full year's leave of absence

— *with* pay. But his 'one year off' affected broadcasting in Northern Ireland for the next twenty years and more. MacNeice made contact with W.R. Rodgers, Sam Hanna Bell and John Boyd, and brought them into broadcasting. And he returned himself—with, in his pocket, *The Dark Tower*, the finest feature ever put out over the airwaves by the Third Programme. Lawrence Gilliam lived and worked according to Albert Camus' principle—'If you lead I shall not follow; if you follow I shall not lead.' His career demonstrates that it *is* possible for an arts organization to be *arts*-led.

When I proposed a modest increase for artists' bursaries, I was invited to write a paper on awards and present it to the Board. Which I did. I was then asked to present my paper to each of the advisory committees and re-submit it to the Board along with a summary of their responses. Which I did. All of this took an age. Eventually nothing whatsoever happened. I secured no extra money for artists. Indeed, the system of pooled awards for all the disciplines which I had administered for several years was dismantled while I was away on sabbatical. At the time—with little or no debate at all—large deficits were being incurred for glamorous imported productions in the Grand Opera House, and then transformed retrospectively into 'Special Grants'. For four nights of Rimsky-Korsakov's *The Golden Cockerel* the deficit was £80,000 —that is £20,000 per night. The annual budget for the traditional arts was then £20,000. The epitaph on the headstone of stillborn or aborted projects might well read: 'Would you write a paper on that, please.'

A few years ago I was anxious that I was going to be overspent in my literature budget. So I heard with relief that since the writer-in-residence at the University of Ulster happened to be a playwright—Martin Lynch—the post would be financed out of the budget for drama and dance. Later I learned of plans to transform the writer-in-residence into a dancer-in-residence. This was

crazy logic. I cared deeply about the writer-in-residence posts, and feared that my little tapestry might unravel without this strand. When I objected I was told that the deliberations of the Drama Committee were none of my business. It took energy-sapping arguments and a sheaf of memos to win back this position for writers. (The first writer-in-residence at Queen's had been John Hewitt; and at the University of Ulster, Derek Mahon.)

In a letter to John Quinn, W.B. Yeats writes: 'It is wonderful the amount of toil and intrigue one goes through to accomplish anything in Ireland. Intelligence has no organization whilst stupidity always has.' Manipulators are the blight of bureaucracy. Governed by short-term political advantage, time-servers, they do not concern themselves with—in Yeats's phrase—gradual time's gifts. If you take them on, you tangle with a tar-baby and end up as besmirched as what you are fighting. Institutions like individuals can go off the rails, and when they do a huge effort is required to take even a few small rational steps.

[IV] The dislikable aspects of bureaucratic life combined spectacularly just over a year ago. I know what happened, but not precisely how and why. What am I about to describe? Vindictiveness? The limitations and complacencies of the provincial mind? Unconscious sectarianism? The freemasonry of the mediocre? Simple ineptitude? All or some or none or one of these? Was this an eerie repetition of the *cause célèbre* of 1953 when, after twenty-three years working in the Belfast Museum and Art Gallery, John Hewitt was cruelly denied the directorship through backroom manoeuvring and for no reason other than his political unsuitability? This removed from the centre of things the most distinguished living Ulsterman. Hewitt had described his emotions as he crossed the Irish Sea on the Liverpool boat:

Round and round the deck I marched, fighting over every known thread of the intrigue. And when the last clumping sailor had pointedly called goodnight and gone below, I still marched on, round and round the deck mechanically. Once I stopped at the rail and looked down at the troubled waters, sliding, folding over, and turning past and, for a minute or more, I was nearer suicide than I shall ever be again.

His detailed account of the affair is called 'From Chairmen and Committee Men, Good Lord Deliver Us'.

The Arts Council in January 1991 appointed Michael Haynes to succeed Kenneth Jamison as Director. The 'Sidelines' column of the February edition of the magazine *Fortnight* noted:

Surprise and controversy have surrounded the appointment of a new director of the Arts Council of Northern Ireland. It had been widely expected that the visual arts director, Brian Ferran, would get the job. Mr Ferran, who is also deputy director of the Arts Council of Northern Ireland, had a distinguished record as a vigorous promoter of Northern Irish artists. But the post has gone to an outsider—Michael Haynes, currently head of arts and entertainment with Hackney Council. ... On the face of it his cv does not appear notably more impressive than Mr Ferran's. And critics reckon it will take him ages to 'learn the language' of the North, given the intricate relations between the arts and society. A local appointment would have made more sense at a time when the region's 'cultural cringe' is receding. If the Arts Council board is—with a few exceptions—the usual undistinguished quango, in one sense it has shown commendable liberalism. The good news is that it has appointed a black Englishman—the bad news is that it has not appointed a Derry Catholic.

Surprisingly, the job description had stated: 'Practical experience in the arts and recent knowledge of Northern Ireland, though desirable, are not essential.' Equivalent Northern Irish posts advertised by bodies like the BBC insist that extensive knowledge of Northern Ireland *is essential*.

Later, Mary Holland wrote in her *Irish Times* column: 'While his background is not immediately relevant to his job application, it would do no harm in the broader political context if a Derry

Catholic were to be appointed to a job with such a high public profile.' She went on to point out that recent surveys conducted by the Fair Employment Commission into employment patterns at the universities showed the under-representation of Catholics in senior posts. She ended her article thus:

I must emphasize that I don't want to question the talents of the new director of the Northern Arts Council. However, one senior academic put the situation to me like this: 'At that level it's always possible to defend the individual appointment. When you get to a choice between two candidates, both of them are likely to be well-qualified. The problem in Northern Ireland is that the decision always goes the same way. The job never goes to the person we can describe as "the Derry Catholic".'

The Arts Council has issued a press release stating that the new Director has been educated 'at the Princeton University of New Jersey before coming to England to undertake his Masters degree at Sussex University'. The new Director came to Belfast to meet his future colleagues. I took a small rational step and phoned friends in Princeton and Sussex. I did so for three reasons: I had met the new Director; I was well-acquainted with his most enthusiastic supporters; and, given past experience, a *débâcle* of some magnitude had been on the cards.

In late April the Council issued a second press release stating that 'for personal reasons' Mr Michael Haynes 'did not intend to take up the post of Director'; and that the Board had met 'and agreed to appoint Mr Brian Ferran as Director'. In *The Irish Times* the following day Anne Maguire (so tragically killed in a road accident two weeks ago [June 1992] and a great loss to journalism and the arts) wrote:

Mr Haynes is understood to have withdrawn after his stated qualifications were questioned. ... It is understood that the council was informed a fortnight ago that he had not obtained these qualifications and subsequent to this, Mr Haynes withdrew.

In London the *Guardian* and the BBC's arts programme *Kaleidoscope* carried the same story. The Belfast newspapers investigated nothing.

In the June issue of *Fortnight* Jan Ashdown asked:

Is everyone just sitting tight and hoping the buck will pass? Why have there not been any resignations on foot of such incompetence? ... Desire for secrecy and anger about disclosure are surely the marks of those more concerned to keep power grasped in tight wee fists than with the discovery of truth. Loyalty is no one's right, any more than is respect—both have to be earned, and one can only be a traitor to an honourable cause. ... The arts are generally thought to be concerned with enlightenment, with the inculcation of civilized values and the development of imaginative moral understanding; artists are 'seekers after truth'. Is it too much to ask the institution that looks after the arts to remember these fundamental principles?

Six months prior to this fiasco I had applied unsuccessfully for early retirement. I was told in a letter that 'since a number of major issues of principle came into consideration, no action should be taken pending the appointment of [the new Director] whose views on long-term staffing development should clearly not be anticipated'. Out of the blue, in March and a month before the new Director withdrew, I was offered a reasonable deal and immediately accepted it. The internal memo announcing my retirement informed colleagues that I would be leaving at the end of the month, in all of ten days' time. My sense of being given the bum's rush was mitigated by what many academic researchers had revealed—facts which, for legal reasons, were still unknown to my employers—and by my knowledge that I was considered a trouble-maker, a likely thorn in the side of the new regime—and better out of the way.

Democracies are controlled by bureaucracies, networks of civil servants, vistas of decent people taking orders and saying 'Yes'. In a bureaucracy it is difficult to remain true to yourself. Facing the 'dark tower', refusing to desert to the system, may help you to

confirm your identity, but at some cost. By more than a coincidence, my first day of freedom saw the publication of *Gorse Fires*, my first collection in twelve years.

[V] As an arts administrator who tried to champion the individual creator and indigenous talent, I was pleased to accept an invitation to join the Cultural Traditions Group at its inception in 1988. Its aims, as I have said, are to encourage in Northern Ireland the acceptance and understanding of cultural diversity; to replace political belligerence with cultural pride. It has been rewarding to watch policy and action proceed hand in hand; to find management lines less rigidly drawn, bureaucracy kept under control; and to work with creative civil servants—life-enhancers within the system.

In the Cultural Traditions Group we expect no quick returns. This is a waiting game. To plan for it in a disrupted social context like our own should not be beyond us. I think of when the British Labour Party came to power in 1945—many schools bombed out of existence; others needing renovation; half a million extra places required; a massive teacher-training programme to be organized; a radical Education Act to be implemented: and all to be financed out of a war-torn economy. This was achieved through the energy, optimism and experimentation of the new government's policy-making procedures. The policy-makers rubbed shoulders with the practitioners. Architects, civil servants, education officers and teachers were not kept in hermetically sealed administrative compartments.

With an initial budget from the government of £3,000,000 over three years, the Cultural Traditions Group has helped to steer grants to local publishers for good books (which would not otherwise be commercially viable) about history, politics, topogra-

phy, folklore, local history; and has made down-payments, as it were, to independent producers for television and radio programmes of similar concern. The Ultach Trust has been established to help fund Irish-language activities, thus grasping a political nettle. The Local History Trust Fund supports the work of the many groups which make Northern Ireland probably the most vibrant corner of Europe when it comes to local history studies. A survey of place-names and the compilation of an Ulster-English Dialect dictionary are under way. There are awards for those who have contributed to the cultural self-awareness of the society; and fellowships for young scholars. These are some of the projects which intertwine with the Education for Mutual Understanding and the Cultural Heritage strands now statutory in Northern schools.

One of the founders of my old school, Belfast's Academical Institution, was the United Irishman William Drennan. He might have been writing a charter for the Cultural Traditions Groups when nearly two hundred years ago he proposed

... the establishment of societies of liberal and ingenious men, uniting their labours, without regard to nation, sect or party in one grand pursuit, alike interesting to all, by which mental prejudice may be worn off, a humane and truly philosophic spirit may be cherished in the heart as well as the head, in practice as well as theory.

The Group not only supports but has learned from enterprises like the John Hewitt Summer School, which over the past five years has made a start by bringing together literature, local history, social and anthropological studies, language, archaeology, the visual arts, topography, music and so on in a spirit of interdisciplinary cross-pollination and under an ecumenical 'regionalist' umbrella.

The tragedy of Ulster brought the Group into being and continues to shape its deliberations. At a meeting I suggested that

our aim should be to lift the community into consciousness and self-consciousness—the forming of a new intelligentsia, if you like—since it is the intellectual (and, indeed, the emotional) vacuum that makes room for the violence. We are involved in cultural preparation, a constellation of conversions, gradual processes which short-term thinking by Government could easily abort.

Sadly, this happened in the case of Conway Mill. The Conway Education Centre in West Belfast offers academic and recreational courses, social events and a wide-ranging cultural programme—including literary readings and debates. Its location means that supporters of Sinn Féin are inevitably involved in the enterprise. It was thus on allegedly security grounds that I was ordered to discontinue Arts Council funding of the Conway Mill cultural programme. I wrote a memorandum to the Chairman and the Director and subsequently read it out at a meeting of the Board in December 1989. I argued that espousal of plurality could not be selective in this way; that withholding funds on the stated grounds strengthened the hand of the paramilitaries against moderating influences inside and outside the community; and that the ban not only damaged the trust which the Council's officers had built up on the Falls Road, but also tarnished their reputation for neutrality and thereby made it less safe for them to work in the area. A thoughtful debate ensued, but the Board did not follow my suggestion that they disobey Government. There was similar short-sightedness with reference to the Glor-na-nGael language-group in West Belfast. Their funding has been restored, but its withdrawal threatened the work of Ultach Trust and the very idea of Cultural Traditions.

[VI] I find offensive the notion that what we inadequately call 'the Troubles' might provide inspiration for artists; and that in some

weird *quid pro quo* the arts might provide solace for grief and anguish. Twenty years ago I wrote in *Causeway*:

Too many critics seem to expect a harvest of paintings, poems, plays and novels to drop from the twisted branches of civil discord. They fail to realize that the artist needs time in which to allow the raw material of experience to settle to an imaginative depth where he can transform it. ... He is not some sort of super-journalist commenting with unfaltering spontaneity on events immediately after they have happened. Rather, as Wilfred Owen stated over fifty years ago, it is the artist's duty to warn, to be tuned in before anyone else to the implications of a situation.

Ten years later I wrote for the Poetry Book Society about what I was trying to do in my fourth collection, *The Echo Gate*:

As an Ulsterman I realize that this may sound like fiddling while Rome burns. So I would insist that poetry is a normal human activity, its proper concern all of the things that happen to people. Though the poet's first duty must be to his imagination, he has other obligations—and not just as a citizen. He would be inhuman if he did not respond to tragic events in his own community, and a poor artist if he did not seek to endorse that response imaginatively. But if his imagination fails him, the result will be a dangerous impertinence. In the context of political violence the deployment of words at their most precise and most suggestive remains one of the few antidotes to death-dealing dishonesty.

Patrick Kavanagh's famous distinction between the provincial cast of mind—abstract, imitative, sterile—and the parochial—close, familiar, teeming with life—applies to Northern Ireland in a particular and urgent sense. Terrified of Irishness—the cultural ideology of the Free State and then of the Republic—Unionists have clung to what after 1968 has increasingly become known as 'The Mainland', and to cultural importation. Those who depend on imports run the risk of themselves becoming exports. In his essay 'Crossing the Border' Hubert Butler describes 'the more formidable of Ulster's enemies' as 'those who keep quiet. "Time is on our side," they are saying. ... "The Province has the artificial vitality of the garrison town and no organic life. If ever the

[25]

pipeline were cut, it would perish.'" He ends his essay by suggesting that 'Ulster would no longer be of value to Ireland if she were robbed of her rich history, her varied traditions.'

Butler thought that reconciliation would not be complete in the South until it had happened in the North; and that it might develop out of regional loyalties. Meanwhile John Hewitt had begun his work of focusing our attention on Ulster's indigenous cultural resources. 'Ulster', he wrote in 1947, 'considered as a region and not as the symbol of any particular creed, can, I believe, command the loyalty of every one of its inhabitants. For regional identity does not preclude, rather it requires, membership of a larger association.' Hewitt did not seem too bothered as to whether that association might be a federated British Isles or a federal Ireland.

Maurice Hayes used to tell a story which regained its currency after Down's victory over Meath in the Gaelic football All-Ireland final last year. Down's first major trophy was the National League in 1960, when they beat Cavan in the final. The captain, Kevin Mussen, brought the cup home to Hilltown in the Mournes—where it rested on the family sideboard. A few days later, the local postman, a Unionist, an Orangeman and a 'B' Special, saw the trophy on his rounds and could not restrain his enthusiasm: 'Jesus,' he shouted, 'we took it off the friggers!'

Here are the ambiguities latent in a sport played by only one section of a divided community and organized by a body which, because of its ideological overtones, is regarded with suspicion by another section. The story also illustrates the problems faced by those who reject the ideological message, but wish to recognize courage, effort, excellence or good performance—or who, in a close community, simply wish to share in the joy of their neighbours' success.

In Ulster, cultural apartheid is sustained to their mutual

impoverishment by both communities. W.R. Rodgers referred to the 'creative wave of self-consciousness' which can result from a confluence of cultures. In Ulster this confluence pools historical contributions from the Irish, the Scots, the English and the Anglo-Irish. Reconciliation does not mean all the colours of the spectrum running so wetly together that they blur into muddy uniformity. Nor does it mean denying political differences. As William Faulkner said: 'The past isn't dead and gone. It isn't even past yet.' But reconstructing the past or constructing identities has too frequently been a purely propagandist activity in Northern Ireland. The Cultural Traditions approach involves a mixture of affirmation, self-interrogation and mutual curiosity. To bring to light all that has been repressed can be a painful process; but, to quote the American theologian Don Shriver: 'The cure and the remembrance are co-terminous.'

We are beginning to find in our own parishes the painful, liberating truths.

THE IRISH WOMAN POET:
HER PLACE IN IRISH LITERATURE

EAVAN BOLAND

My subject today is the woman poet and the national literature of Ireland. It may well seem—with such a subject—that my emphasis should be on finding a context for the Irish woman poet in that literature. But it is not. Even the words *finding a context* are, I feel, misleading. They imply permissions and allowances—a series of subtle adjustments made to fit a new arrival into an established order. I want to make it clear from the start that this is not my view. It seems to me critical to any accurate or useful interpretation of this subject—which remains a difficult and controversial one—to insist on this point. I want to make it very clear from the beginning—and my lecture is candidly shaped around my beliefs—that any relation between the Irish woman poet and the national literature is a two-way traffic. That in the process of finding a context in Irish literature through her work, the woman poet also redefines the part of that literature which she enacts: namely Irish poetry. She also redefines the relation between the national ethos and the Irish poem. I am not, in other words, talking about some grace-and-favour adjustment of Irish poetry to

allow for the new energies of Irish women poets. I honestly think this is a doomed approach. I am talking about taking this chance—of new work and radical departures—to look again at Irish poetry and revise certain assumptions about it.

In his *Modern Poetry: A Broadcast* Yeats makes a striking comment on T.S. Eliot. 'In the third year of the War', he says, 'came the most revolutionary man in poetry during my lifetime, though his revolution was stylistic alone—T.S. Eliot published his first book.' It is of course possible to read this assertion—that Eliot was a radical stylist but little more—as a conservative, not to say grudging, retrospect. I think a better way to read it reveals the opposite: that it is, essentially, the rebuke of one great modernist to another—a rebuke which suggested that Yeats felt Eliot had interpreted the letter of modernism, but may have imperfectly developed its rigorous and rewarding spirit. It also—and this is what concerns me here—contains the implicit warning that changes to poetic form need to happen at levels deeper than language, mannerism, or influence; that they must go well beyond those gestures of expression which seem to promise a temporary shift of fashion or response.

I have this warning in mind as I speak here. To sustain my view that women poets are influencing the form they enact I want to propose a substantive argument for it—one that goes beyond changes in style or taste. Put as simply as possible, my argument is that both the Irish poem and the perception of it are radically changed by the fact that Irish women—within the space of a couple of decades—have gone from being the objects of the Irish poem to being the authors of it. This does not just mean that Irish women now write the Irish poem—although they do; it means they also claim it. Not as their own, I should quickly add: a claim of ownership should not and cannot be sustained in any art form. Claims of ownership are, in many ways, what women poets have

implicitly contested by writing the Irish poem. Nevertheless they do something exciting and unusual with that poem. Inasmuch as they are the old silent objects of it, now transformed into speaking parts and articulate visions, they make a momentous and instructive transformation in Irish poetry.

And of course, a contentious one. By enacting their experience and expression within that poem, they have disturbed certain traditional balances in the Irish poem, between object and author, between poet and perspective. These balances were themselves an index and register of an old relation between the Irish poem and the national tradition. Perhaps, at this point, I should change the *they* here to *we*. In disrupting such balances, Irish women poets such as myself and Nuala ní Dhomnaill and Medbh McGuckian and Paula Meehan have disordered an old, entrenched and even dangerous relation between Irish national assumptions and the Irish poem. Therefore, although I won't say that Irish poetry is at a crossroads, I will say that I believe it has changed. The landscape of it will never be politicized in exactly the same way again. The features of it will never be susceptible to the same definitions again. And the old critiques will not serve any more in the new situation.

It is always tempting—to choose Yeats's word again—to claim a revolution for the work of any poetic generation. But it is rarely true. And in this case, also, I think there are precedents for the way Irish women poets and Irish poetry connect. I think the mode of connection—the relation of a disruptive energy to a national literature—goes back further than this moment in which poetry by Irish women has become a presence. I think of Irish women poets as refusing the passivity offered them by the inscriptions of a national literature. Their refusal makes a crucial difference and occurs in a crucial area; and I will return to be as precise as I can about it. But in my time, as a young poet in Dublin, I saw and

was moved—and I think was also influenced—by the way in which other poets refused different but similar simplifications. I am especially thinking of Patrick Kavanagh. As a poet—like so many of my generation—I continue to find him a liberating force and a poignant, living presence. I am still struck by the way he threw aside shibboleths and symmetries which it might have been thought he would live into, or at least write into. He resisted stereotypes, albeit with pain; he redefined his own power, albeit at cost. Whenever I want to measure that rare and elusive quality which is imaginative courage, I think first of him.

These are affinities and influences, however, they are not critical models. I think it is important to highlight that there is no pre-existing critique for the particular conjunction I am speaking about: the emergence of a woman poet against a backdrop of a strong and entrenched national tradition. There are poets such as Anna Akhmatova in Russia who were luminously aware, largely through their own experience of it, of the encroachments of power. There are poets like Emily Dickinson who defined, in her writing, an important puritan ethos, even while she was being eclipsed by it. There are writers like the Afro-American poet Gwendolyn Brooks who lived at the intersection of race and expression. She speaks for many of the others with her words: 'I have heard in the voices of the wind my dim killed children.'

Nevertheless, the Irish situation is different. It requires a radical and thoughtful approach. It has been, in some senses, stressful for women poets such as myself to have to make the critique, at the same time as we are making the work for which the critique is fitted. I'm afraid it is a measure of the intermittent nature of scholarly discussion throughout the seventies and eighties—and what I feel has been a signal failure of the scholarly conferences in this regard—that there has been, until recently, no searching and eloquent critical literature to cover this subject, although there is

almost an embarrassment of it in other areas of contemporary Irish poetry. This in turn reflects the assumptions—barely stated but easily sensed by a poet like myself—that, while women poets might contribute individual poems, they were unlikely to shift or radicalize the course of Irish poetry itself. I believe there cannot be a sound critique which does not recognize the possibility of their doing so. No poetic tradition is a static or closed entity; it lives to be refreshed and re-stated, to be strengthened by subversion. In the absence of such a critique, an analysis of the position of the woman poet in the national tradition and literature has only been brought forward through personal witness and private argument. I intend to continue this here.

'Poetry', said Rilke, 'is the past that breaks out in our hearts.' The relation between Irish poetry and the Irish past has always been a subtle and uneasy one. The writer Francis Stuart made a distinction in a letter to *The Irish Times* many years ago. It was a distinction between the state and the nation. The state, he argued—I'm paraphrasing him here from memory—is an expedient construct. It is made of all the downright, day-to-day compromises which everyone perceives as necessary and no one feels bound to. The nation is something different. It is—I am continuing to paraphrase his argument—both more fragile and more communicable: composed of the invisible and the irreducible, and independent of the expedient. Every Irish person has been touched by that nation. Whether they live in Ireland or outside it, anyone who is Irish has encountered it. Whether it emerges for them in songs and stories in childhood, or in reading at a later time, they are aware of it. How they are aware of it is a different matter. There are those who adhere to its visible history; there are those who manipulate it; there are those who are imposed on by it. And

[II]

there are those—and I include myself—whose first contact with it was through its ambiguities.

The Dublin I began to write in was the Dublin of the early sixties, whereas the Dublin Patrick Kavanagh came to from Monaghan was the Dublin of the late thirties. Vast changes separated those cities: of outlook and custom and politic. Yet both of them —in the narrowly literary sense—were alike in one sense: they remained influenced by the conjunction of the national ethos and Irish poetry. It was not a fortunate conjunction. Kavanagh makes this bitter comment about it in his *Self Portrait*. 'When I came to Dublin', he wrote there, 'the Irish Literary Affair was still booming. It was the notion that Dublin was a literary metropolis and Ireland as invented and patented by Yeats, Lady Gregory and Synge, a spiritual entity. It was full of writers and poets and I am afraid I thought their work had the Irish quality.'

The Irish quality, Kavanagh's acid reference to it is revealing. It suggests the tension between the private intelligence of the poet and the painfully limiting role he or she may be offered by a national literature. In the objective sense Kavanagh was grappling with something which I would see differently in another generation. The mediation which the Celtic Twilight performed—a mediation of national energies into the Irish poem— had severe consequences for Irish poetry. To start with, Irish nationalism, as it seeped through the rhetoric of the Celtic Twilight, had a heavy and corrupt investment in a false pastoral. Poets like Kavanagh were intended to exemplify the oppressions of Irish history by being oppressed. Kavanagh resisted. He rejected a public role in favour of a private vision. It was a costly and valuable resistance—exemplary to poets like myself who have come later, and with different purposes, into the tradition. I can still be heartened by his defiance of the aftermath of the Twilight—clearly audible in a remark like this, which is also from

Self Portrait. 'In those days in Dublin', he wrote, 'the big thing besides being Irish was peasant quality. They were all trying to be peasants. They had been at it for years but I hadn't heard.' Kavanagh's downright critique of the expectations placed on an Irish poet—albeit in another time—illuminates an aspect of the relation between the Irish poem and the Irish national literature. It also demonstrates that these tensions predate women and their poetry in Ireland, and so may occur whenever a new energy menaces the old configuration of Irish literature.

Heartened by this, I also have a critique to offer. To start with, I challenge certain traditional assumptions about Irish poetry. To say that Irish poetry has taken place against the backdrop of Irish history, which of course it has, is not the same thing as saying that the Irish national ethos has been good for the Irish poem. The two things should not be confused. Irish history is a given; we are all constructed by that construct. The Irish national idea, on the other hand, has always been involved in an ambitious series of propositions. These may have been valuable as articles of faith; they have no value at all as an aesthetic. In putting together the argument of the way in which the Irish woman poet finds a context in a national literature, I am unapologetic about saying that one of the real values—although an extra-poetic one—of women's poetry in this culture is that it shows up the flaws of the relation between Irish poetry and the national ethos. It opens a window on those silences, those false pastorals, those ornamental reductions which a national idea prepares for any literature it hopes will do its work of simplification.

In one important area, where the land and the nation and the feminine figure all come together, the national ethos has instructed the Irish poem in stylization which have held it back and restricted its idiom. It is important to emphasize that these stresses have not been created by the work of women poets; they

have been revealed by them. The best Irish poets have been aware of the dangers of the national tradition; the best work of Irish male poets has always been private, obsessive and powerful. But there remains in Irish poetry written by men—both in contemporary poetry and the poetry of the past—an available and availed-of image. If I call it Cathleen ni Houlihan or Dark Rosaleen I am only giving it disreputable names from another time. But the fusion of the national and the feminine—the old corrupt and corrupting transaction between Irish nationalism and the Irish poem—continues to leave its mark. It is this which the poems of women and by women have disrupted; it is this which their poems have subverted. Irish women poets can therefore be seen as the scripted, subservient emblems of an old image file come to life. In a real sense, the Irish woman poet now is an actual trope who has walked inconveniently out of the text of an ambitious and pervasive national tradition, which found its way into far too much Irish poetry. Her relation to the poetic tradition is defined by the fact that she was once a passive and controlled image within it; her disruption of that control in turn redefines the connection between the Irish poem and the national tradition. And for all these reasons I value the disaffected intelligence of a poet like Louis MacNeice who wrote in 'Autumn Journal':

> The land of scholars and saints:
> Scholars and saints my eye, the land of ambush,
> Purblind manifestos, never-ending complaints;
> The born martyr and the gallant ninny;
> The grocer drunk with the drum,
> The land-owner shot in his bed, the angry voices
> Piercing the broken fanlight in the slum,
> The shawled woman weeping at the garish altar.
> Kathleen ni Houlihan! Why
> Must a country like a ship or a car, be always female ...

It stands to reason that poets like Kavanagh and MacNeice,

given their time and formation, did not anticipate the role of women poets in Irish poetry. But they addressed tensions which are held in common. Their voices have been a source of information and sustenance in the sometimes difficult task of tracking down those tensions and isolating their effect in Irish poetry. That search has had personal aspects and I think it is pertinent to my argument to speak about those now.

I grew up largely outside Ireland. I left at five and returned at [III] fourteen. More importantly, I grew up in a diplomat's house where Ireland was the fictive construct around which our daily life was arranged. My father represented Ireland in Britain. Before that, he had been part of the negotiation by which Ireland's transition to the status of republic in the later forties had come about. Ironically, the success of those negotiations, and the achievement of the Republic on foot of them, guaranteed my absence from it.

The outcome of all this was geographically simple and imaginatively complex: I grew up outside Ireland; and I had a nation long before I had a country. It came to me through snatches of conversation, through the unspoken absences of landscape and accents, and through the sentimentalizations which all absences encourage. I listened carefully to the songs and stories, most of which were thrilling and puzzling at the same time. At night I could hear Tom Moore's melodies being played; I could read Mangan's 'Dark Rosaleen'. A little later, when I was a teenager, I heard Yeats's *Cathleen ni Houlihan* recited on record. It is easy to say now that these were flawed images. The fact is, they were filtered through absence and nostalgia; they stood in as sign for something. That something may have been nothing more—as can be the case with exile—than my own distance from the ambiguities they disguised.

It might have remained like that except that I left school, went to college and began to publish poetry. I don't think I was particularly sceptical about the nation at that point. I had grown up outside Ireland; I had heard all the songs, the ballads, the formulae of an oppressed entity which are so powerful and so appealing. Which are beyond intelligence; beyond resistance. The first poem I published was called 'A Cynic at Kilmainham Gaol'. I had no special insight into the flawed connection between a nation and its images. My scepticism, when it came, was not about the nation. It was about the Irish poem.

Is there such a thing as an Irish poem? The question remains a very open one. But there is in any poem, when you disassemble it to look at it more closely, a series of tensions and oppositions which you can see clearly once you look. There is, for instance, in every poem, in every language, the poet's experience and the poet's expression of it. The poet's experience can be of love, or sexuality, of remembrance or disappointment or regional affection. The poet's expression of it is another matter. It is the expression of it, with all its complexities of language and inheritance, that is likely to be instructed, or obstructed, by elements other than private human experience. By nationality, or ideology or polemic. I became powerfully aware in the Dublin of the sixties, although I had no words for it at that stage, that certain elements of experience were, or had been, obstructed by certain elements of expression.

Later I would connect that intuition with the fact that Irish poetry of the forties and fifties—and this was still visible in the sixties—was emerging from a bruising struggle with the aftermath of Yeats. Similarly, Irish poets were emerging from the unnerving relation which the Celtic Twilight has established between the so-called Irish experience and the Irish poem.

Inescapably, Yeats is at the centre of this. No other poet will

ever mean so much to me as him, and yet he is open to criticism on this account. To go back to that important question—is there such a thing as the Irish poem?—it is clear Yeats thought there was. But the poem he handed on was nevertheless a poisoned chalice for the generation after him. As a construct, it had been supremely useful to Yeats who knew how to make the Irish cadence, and the Agonistes stance, disrupt the English tradition. But for the poets who followed him, the poem they inherited as a model was an out-of-focus snapshot. By example and insistence, Yeats communicated a poem which was stranded somewhere between British Victorianism and Irish invention. At its worst, it was the poem of what Samuel Beckett called, with wonderful precision, 'The Victorian Gael'. If like Yeats you were the foreground of that poem—an angry, eloquent and isolated close-up—then what was in the background did not matter so much. If like Fallon, Clarke and Kavanagh you were lost figures in the unfocused background—where the faint shapes of beasts and trees and people happened in a simplified history—then your task was daunting.

These poets had to take that poem, used with such brilliance by a great poet—but inhospitable to their dignity, their identity, their Irish past—and re-work it. They had to write a whole psychic terrain back into it; an act made more difficult in that Yeats had blurred that terrain with the power and enticement of simplification. They had to resist those simplifications and restore that complexity. Certainly we have cherished them in our way. But I am not sure we have given them credit for the huge task they faced, the magnetic field they worked in, their stubborn courage. They are the ones who picked up the fragments of a broken mirror and magically repaired them so that we saw ourselves whole. To paraphrase Eliot, if we know more than them it is because they are what we know.

By now, in a later generation of Irish poetry, I think we've accepted the fact that the Celtic Revival was a powerful, exclusive and necessary strategy, heavily invested in the passivity of certain images. These images constituted the elements of a false Irish pastoral. That pastoral in turn was necessary to supply the Celtic Twilight with its subtext that Irish culture was somehow both violated and inviolate. The dark side of all this was that Irish poets after Yeats were regularly screen-tested for their supporting roles in this pastoral. It's this in particular, as I've already said, that led Patrick Kavanagh to be so articulate and rhetorical and bitter.

Kavanagh's anger hints at something which the Irish poets of his generation had to deal with. A complex series of evaluations and devaluations; a fragile and dangerous spiral by which their worth—put under stress once by British colonialism—was again called into question, and this time more poignantly and ambiguously, by the towering achievement of a poet with a selective and reactive view of the Irish experience. The origin which inspired them was also the source which menaced them. I take nothing away from Yeats when I argue—as many others have—that he widened and deepened his theme of private humiliation by fuelling his argument of a public siege mentality. The dual heritage he left behind was one of the absolute power and redemption of the private theme; and the exclusive and self-deceiving elements of the public one.

The Celtic Twilight therefore had mediated a national tradition into a position of commanding influence on the Irish poem. When I began to write and publish poems in the Dublin of that era I gradually became aware—once again it was a slow and intuitive process—that although the Celtic Twilight itself was over, there remained a series of subtle, negative permissions surrounding the Irish poem and Irish poetry. The series of evaluations and

devaluations remained. In my case they were held in place, not by a false pastoral—that had gone forever with Kavanagh—but by the intertwining of the feminine and the national.

The poem I inherited contained passive, ornamental images of women. This was particularly true where the woman in the Irish poem in any way suggested the generic, the national, the muse figure. The result of this was not aesthetic; it was highly practical. I took away with me from Dublin, and from Trinity College, a certain kind of Irish poem which was recommended and visible and considered suitable. The national ethos, as it had been allowed into Irish writing, continued to issue certain permissions as to what the poem could be about. You could have a political murder in it; but not a baby. You could have the Dublin hills; but not the suburbs under them. This is a vital point in considering the poem written by the Irish woman poet. The life of the Irish woman—the ordinary, lived life—was both invisible and, when it became visible, was considered inappropriate as a theme for Irish poetry. A language of criticism grew up about this. Certain poems were deemed to be 'by women' and 'for women'. The assumptions implicit in that language were that women wrote poems for the constituency of women, and about it. But that these poems were not to be considered binding upon, or subversive of, the mainstream of Irish poetry.

The challenges for women poets in the middle of all this were, and are, many. On the one hand they could disrupt the permissions issued by the tradition of Irish poetry and put their lives— their gardens, their friendships, their washing-machines, their vision of the connection between their life and its expression— into the Irish poem. They have done this; they continue to do it. Women poets in this country whose work I admire and value, such as Paula Meehan and Eiléan ní Chuilleanáin and Nuala ní Dhomhnaill and Medbh McGuckian—and there are others—are

doing this. When Paula Meehan writes about her mother in 'Versions' or Medbh McGuckian canvasses the theme of dislocation in 'The Flitting', they are primarily writing good poems. Those poems will be read and valued in places where there is no knowledge of the disruption they caused, the balances they upset, the traditional silences they broke. But the fact that they did all this adds power and poignance to the context. And a generous restructuring of context is at the heart of some of the points I have proposed here today. As I come towards the end of this lecture, I want to summarize some of these points.

[IV] Every new generation of poets, every new departure in poetry— and Irish women poets at the moment constitute both—dramatizes the fact that a poem is assembled in several ways. What I have described here today is a personal perspective on some of the tensions in the Irish poem. Of course, the perspective through which an experience is mediated in any poem is, at least partly, the one of the human being who is writing that poem. They are looking back, or looking in, or looking down. They are writing out of love or obsession or hate or emotion and tranquillity, or whatever you like. The part of the poet which is still bound by the experience can be fresh and engaged and innocent of any intervention by ideology or prejudice. But the expressive intelligence of that poet—which can be quite different—is open to many influences.

It has seemed to me that the expressive intelligence of many Irish male poets writing about women—and very much where the image of women inflected the image of the nation—was instructed by the national ethos in a limiting way. This expressive intelligence often obstructed the experience in the poem and turned the woman as subject into the image as object. I have

chosen not to go into all the examples in which I see this in the work of male poets of this century in Ireland. Those examples are controversial, and what one person sees another can discount. But I am quite certain that the compound effect of those instructed intelligences was to make the Irish poem unavailable to the ordinary downright and lived experience of women. The result was that the confidence and access of Irish women poets was very much affected by the fact that many of the feminine images in the poetry they inherited partook of the larger confusion between the national and the feminine. For a very long time—in our ballads, our aisling poems of the eighteenth century, our nineteenth-century patriotic verse up to and past Yeats—the feminine drew authority from the national in an Irish poem, and the national was softened and disguised through the feminine. I can't think of anything more disruptive than that Irish women poets within a generation should alter that arrangement and break the terms of that long-standing contract.

The Irish poem, as it now exists, is a changing interior space. It no longer has predictable component parts. Above all, the historic transaction between the passive/feminine/national and the active/expressive/male Irish poet has been altered. I don't think it will be re-established. Because of that shift I think we can see more clearly how profoundly nationalism—with all its colours and shadows—is invested in passive feminine images within the Irish poem. Therefore a whole foundation has been undermined, a whole edifice has been and can be cracked, because this shift has happened. With the right openness, the right approach, there is now a chance to look at the past and present of Irish poetry in a fresh and vital way.

Much of this has come about without the help of a pre-existing critique. In fact, with rare exceptions, there has been almost the opposite over the last decade. There came to be an unspoken

perception that the poem written by a woman might not exactly be an Irish poem. I was often aware, and often contested, a damaging suggestion in the air that Irish poetry was one thing—with a clear line of succession and a recognizable assembly of themes—whereas poems by Irish women were something different. Maybe to be accepted; maybe to be valued. But not really to be taken as Irish poems.

What I have said today must make it obvious that I challenge this idea. I think it is damaging in equal proportions to poetry written by women and to Irish literature. The poetry being written by women in Ireland today is Irish poetry. It stands in the mainstream of that valuable tradition; and like all such entries into a tradition, it re-orders what is there.

When I was a young poet the restrictions and flawed permissions of the poem I inherited, and the climate I wrote in, were acute enough that it seemed I would be faced by an ethical choice I could not make and would not want: that I could only be the woman poet I wished to be if I turned my back on the power and enrichment of the national tradition. Or that I could be an Irish poet, but only at the cost of exploring my identity as a woman poet. At that point it seemed that my Irishness and my womanhood were on a collision course in my poetry.

It did not happen. The choice was illusory. But it intensified my commitment to see in Irish poetry a diverse and challenging critique. Which will allow for new energies and stern tests. Which will not marginalize the awkward and subversive. Which makes generous gestures to the new and disruptive. I do not know how this is going to happen if there is not a new way of thinking to go with a new way of writing the Irish poem.

I want to be as candid at the end of this lecture as I was at the beginning. I believe there has been real resistance to the views I propose here among the community of scholars who write about

Irish poetry. The connection between Irish women poets and that community has not been, in my view, especially useful or illuminating. There are, of course, sustaining exceptions. But by and large there has been a scholarly tendency to consider poetry by Irish women poets as an inscription on the margin of Irish poetry. I do not hold this view. I do not think it is an accurate view. I do not think it serves Irish poetry well. I think it is partially responsible for the mistaken exclusions—and subsequent distortions—in the recent *Field Day Anthology of Irish Writing*.

Because of the rearrangements and the innovations of the recent past, a woman in Ireland who wishes to inscribe her life in a poem has a better chance now to move freely around within that poem, to select its subject and object at will, and to redirect its themes to her purposes. I would be deeply disappointed if this were construed, at this late stage, by this scholarly community as merely an advantage to women poets in Ireland. It constitutes an increase in artistic freedom, a precious addition of idiom and vista in what is already one of our most precious possessions: the Irish poem.

THE SPIRIT OF PLAY
IN OSCAR WILDE'S DE PROFUNDIS

FRANK MC GUINNESS

That wise woman, Cecily Cardew, says of her diary in *The Importance of Being Earnest*, 'It is simply a very young girl's record of her own thoughts and impressions, and consequently meant for publication. When it appears in volume form I hope you will order a copy.' She reveals here a seductive cunning that, allied to a fine commercial brain, augur well for her success in the game of love and chance that is marriage. She is addressing her future husband, Algernon, who is the imaginary subject of so many entries in this diary, and she is at once enticing and distancing, as she creates for him a character and a history of which he has no knowledge. This elaborate history centres upon their engagement which, he learns, was settled with suitable ritual on Valentine's Day, 14 February last. Presents have been given, 'neatly numbered and labelled ... a ring ... a pearl necklace ... a little gold bangle with a turquoise and diamond heart'. Most significantly, she can produce a box where she has kept all his letters to her. He protests he has never written any letters to her. Cecily replies, 'I remember it only too well. I grew tired of asking the postman every morning if he had

a London letter for me. My health began to give way under the strain and anxiety. So I wrote your letters for you.' Here there is, obliquely, a hint of prophecy, as this episode anticipates the composition of *De Profundis, Epistula: In Carcare et Vinculis*, where Wilde wrote, 'Every single work of art is a fulfilment of a prophecy.'

De Profundis was written in 1897 to Lord Alfred Douglas, Bosie, a few months before Wilde's release from Reading Gaol near the end of his two-year sentence for 'acts of gross indecency with other male persons'. It could be regarded as an argument outlining Wilde's spiritual and sexual evolution, conveying the sincere feelings of the sinner who has converted into a penitent. It might equally be regarded as a love letter to Bosie, terrifying in its accusations and admissions, a fucking by verbal force, a demanding of rights. Its title and subtitle carry scriptural connotations, and Wilde is too skilled a playwright not to demand his title be his guide. The cry of 'De Profundis' itself comes from Psalm 130:

Out of the depths have I cried unto thee, O Lord.

Lord, hear my voice: let thine ears be attentive to the voice of my supplications.

If thou, Lord, shouldest mark iniquities, O Lord, who shall stand?

But there is forgiveness with thee, that thou mayest be feared.

I wait for the Lord, my soul doth wait, and in his word do I hope.

My soul waiteth for the Lord more than they that watch for the morning: I say, more than they that watch for the morning.

Let Israel hope in the Lord: for with the Lord there is mercy and with him is plenteous redemption.

And he shall redeem Israel from all his iniquities.

Supplication, iniquities, forgiveness, waiting, hope, redemption—this is the Pilgrim's Progress of Wilde's text, if its controlling image is that of a man *in carcere et in vinculis*, if its justifying voice is that of the penitent at prayer. This is indeed Wilde's reductive desire at certain points in this letter, when he wishes

'Humility' on himself and on Bosie. But Cecily Cardew's invaluable advice to authors must be heeded. Whatever is written can be published, and whatever is published is performed. *De Profundis* is not the meditation of a penitent at prayer. It is the act of a penitent as performer. It is a histrionic defiance against the histrionic judgment passed against Wilde at his trial, a theatrical explosion to break the silence of censorship that his prison sentence demanded, it is a play.

It is a strange play that limits itself to one spectator, but not so strange when it is realized that this play wished to create its spectator as much as its spectacle. Two characters propel the action, Oscar and Bosie, the writer and the written. Not since Shakespeare's purification of the role of actor through the part of Prospero in *The Tempest* has any playwright made such correspondence between the initial participants in the act of making theatre. And Bosie is Ariel transformed into Caliban, he is Miranda and Ferdinand turned into Antonio and Sebastian, while Oscar is Prospero rewritten, having had his magic renounced for him. As in *The Tempest* a revenge must be taken, and revenge in *De Profundis* does not depend on magic but meaning, and the meaning is clear: Bosie destroyed Oscar's life because he destroyed Oscar's art. To recover that magic, that art, will require another act of destruction. This destruction will unleash itself through a tempestuous reply to Bosie's chaotic arrival and influence on the order of Oscar's life. The form this reply takes is soliloquy masked as dialogue, for it is written in a letter, and letters anticipate an acknowledgment. 'I have yet to know you. Perhaps we have yet to know each other', Oscar slyly concludes in *De Profundis*, after he has instilled his knowledge of all involved in this drama.

Drama it was, this relationship. The text repeatedly documents the ecstasies and exploitations, the cruelties and deprivations of their courtship and affair. That it had soon ceased to be sexual

intensified the addictive dependence. That dependence is accounted for in the lists of financial recriminations, the presents given and taken, 'numbered and labelled', as Cecily foretold. Page after page records the screaming pitch of this melodrama, and acting as unifying motif through this 'terrible letter' are the many, many references to their previous letters. Loving letters of flirtation, abusive letters of rejection, pleading letters for forgiveness, concerned letters from Bosie's mother, all this writing leading finally to Bosie's father, the Marquess of Queensberry's scrawled note of sexual accusation that led to Wilde's downfall. Oscar observes how his wife Constance once joked that he received so many letters from Bosie's mother that they must both be collaborating on a 'secret novel'. This epistolary novel ended up as no secret, and its tale once told brought ruin on the hero.

Oscar berates Bosie most viciously for the 'careless want of appreciation' that allowed him to leave Wilde's letters 'lying about for blackmailing companions to steal, for the servants to pilfer, for housemaids to sell'. But this whole motif of these letters is underlined by one great roar of desire. Oscar wants Bosie to write to him. The admonishing speech, the recriminating sermons, they are the tactics of an author deprived of his audience, so deprived it becomes necessary to invent its existence, and in that invention thereby invent himself. As the invention expands in the course of the letter to include all humanity in the suffering of the creator, so paradoxically does it contract until the audience is intensified into a single individual, created in the image of an unsuffering spectator. If all others are to share Oscar's suffering, then Bosie stares at it. Enduring his tragic fate, Oscar allows us empathic access to his prison cell. He tells us that the censorious regulations of the prison system allowed entry to his enemies, not his friends, but through taking advantage of his empathic access we have, like Oscar, defied his/our enemy and become friends. Yet

one man defies the categories of enemy and friend. He is allowed such powerful defiance when he is created in the role of neither enemy nor friend, but in the role of lover. The lover maintains one mysterious power over Oscar. This is his silence. If Oscar asks us for our sympathetic eyes and ears to see and listen, then he is also ultimately asking Bosie to speak.

In *De Profundis* Oscar calls himself 'the lord of language'. Bosie is *Lord* Alfred Douglas, and the similarity of the titles is not accidental. Oscar may mock Bosie's vanity over his 'little title', but so too does Bosie's silence mock 'the lord of language'. It is a silence that threatened to strike Oscar dumb, and fearing that threat, Oscar turns in his defence to the Saviour of 'those who are dumb under oppression and whose silence is heard only by God', he turns to the figure of Christ. Identifying the precise figure of Christ is one of the key conflicts in the drama of *De Profundis*. If the voluble Oscar and the silent Bosie dominate the text, then midway through the action a crucial other presence is felt, and that is Wilde's creation of the character of *Christ*.

The first question to pose itself is obvious. Is this character a mirror image of Oscar himself? 'Feasting with panthers' is of course Wilde's own famous description of having 'entertained at dinner the evil things of life'. The pleasure of their company lay in their very danger, for 'the danger was half the excitement'. Into what danger does Wilde now tread? Is the tragic chorus from *The Ballad of Reading Gaol* a clue?

> Yet each man kills the thing he loves,
> By each let it be heard,
> Some do it with a bitter look,
> Some with a flattering word,
> The coward does it with a kiss,
> The brave man with a sword.

The kiss of Judas and the betrayal by Bosie find easy parallel, but

The Ballad of Reading Gaol is, as its echoes of *The Merchant of Venice* here hint, a meditation on justice and punishment. Any trace of a Messianic complex is kept to the periphery of the poem.

No such escape is possible in *De Profundis* with its concentration on suffering and the redemption that follows suffering. To map out our way through this terrain we must look for helpful clues, and the most helpful is the most ingenious statement made in *De Profundis*, when Wilde declares of the text, 'There is nothing in it of rhetoric.' The character of Christ is Wilde's supreme rhetorical creation here. This Christ is securely literary artefact. Oscar and Bosie bear within them the functions of their external histories to influence their dramatic development, but Christ is a creature of Wilde's pure imagination, as ahistorical as Salome, as tantalizing as Willie Hughes. In *The Soul of Man Under Socialism* Wilde defends artists against over-identification between them and their subjects, 'To call an artist morbid because he deals with morbidity as his subject matter is as silly as if one called Shakespeare mad because he wrote *King Lear*.' Oscar is tempting fate by calling Christ to his side, but Wilde is too expert a dramatist and too good a critic to equate the two. So who is the Christ of *De Profundis*?

A creature of pure imagination, a literary artefact. What is remarkable about this character of Christ lies not in any similarity he shares with Oscar but in the precise dissimilarities which contrast him with Bosie. When we remember Douglas's dismissal of Wilde's Irishness in his life of Oscar Wilde, not the least of these dissimilarities is Wilde's erroneous claim that Christ is like an Irishman. He associates the bilingualism of the Irish peasant with that of the Galilean peasant of Christ's time. Speaking in specific terms of Bosie's family and his own relations with it as 'the ruin of your race upon mine', Wilde extends his private grief into a national grief. Douglas, the English aristocrat, is pilloried

as a fraud, his sensibility derided as sentimentality, his sophistication dismissed as cynicism, such sentimentality and cynicism being 'the perfect philosophy for a man who has no soul'.

The soulless Bosie is mocked as 'Philistine', lacking all talent, being utterly devoid of imagination, embodying the supreme vice of shallowness, and being pathetically vain of his 'little title'. His every cultural aspiration and political illusion stand maligned. They are the false and indulgent fantasies bestowed on Bosie by Narcissus, Bosie's self-love, and the great rival to Oscar's love. Wilde cleverly redraws the points of reference that constituted the relationship's original triangle, namely Oscar, Bosie and Narcissus. He substitutes for Narcissus the character of Christ. He thereby replaces his own rival with Bosie's rival, Christ. Everything Christ is, Bosie is not. Everything Bosie wishes to be, 'a poet ... a close union of personality with perfection', Christ already is. Under the guise of spirituality, this sexual taunting is savage. Christ may have been a 'young Galilean peasant', but he is more noble than the aristocratic Bosie because Christ's 'morality is all sympathy'. To Christ, imagination is simply a 'form of love'. Sympathy, imagination, love—Christ is assuming the status of a perfect partner. Made divine by that moral sympathy, illuminated by that imaginative love, Christ obtains the ultimate accolade, 'He is just like a work of art himself.' He is desire personified, his life eulogized as 'the most wonderful of poems', for out of his own imagination entirely 'did Jesus of Nazareth create himself'.

Throughout *De Profundis* Wilde repeatedly bows to Dante as the supreme literary authority, through references to *La Vita Nuova* and *The Divine Comedy*. And Christ has become Oscar's Beatrice, whose physical grace once glimpsed becomes the guide to great light through great love. Christ has, it appears, replaced Bosie, and it is Oscar's turn to do the rejecting. The play of *De*

Profundis continues its plot. The discarded lover can now do the discarding with all the simple, powerful logic of a ballad or folk tale. Justice, not jealousy, is the motive. There is about it all an air of inevitability. This is what must happen for the song to be sung, for the story to be told. There is in *De Profundis*, as there is in all of Wilde's major writings, the sense of a folk-tale. His parents, Sir William and Lady Wilde, were collectors of stories, and his first great fictions were fairy-tales. His stories for the stage have miraculous revelations at the core of their narratives. There is nothing more miraculous than the perfect plot of *The Importance of Being Earnest*. There Miss Prism, that failed novelist, declares, 'The good ended happily, and the bad unhappily. That is what fiction means.' The folklorist knows differently, knows better. The stranger the story, the stronger the story, and Wilde tells us in *De Profundis*, 'behind sorrow there is always a soul'.

Oscar may be in the process of selling his soul to Christ, but there is one who can stop this salvation, and save Oscar for himself. That one is Bosie, who can prove his power by replying to this letter. He provides Bosie with dangerous, irresistible information—Oscar may still be saved for damnation:

As regards your letter to me in answer to this, it may be as long or as short as you choose. Address the envelope to 'The Governor, HM Prison, Reading'. Inside, in another, and an open envelope, place your letter to me: if your paper is very thin do not write on both sides, as it makes it hard for others to read. ... What I must know from you is why you have never made any attempt to write to me, since the August of the year before last, more especially after, in the May of last year, eleven months ago now, you knew, and admitted to others that you knew, how you had made me suffer, and how I realized it. I waited month after month to hear from you. ... There is no prison in any world into which Love cannot force an entrance. If you did not understand that, you did not understand anything about Love at all.

The need for the lover details its pain, its anxiety, the 'numbered and labelled' dates of correspondence and communications,

and desire for contact, the longing for the real presence, albeit transubstantiated into pen and paper. The confrontation between writer and written collapses. A cry comes from the heart, and it's to hell with the soul:

Let me know all about your article on me for the *Mercure de France*. I know something of it. You had better quote from it. It is set up in type. Also, let me know the exact terms of your Dedication of your poems. If it is in prose, quote the prose: if in verse, quote the verse. I have no doubt that there will be beauty in it. Write to me with full frankness about yourself: about your life: your friends: your occupation: your books. Tell me about your volume and its reception.

Write to me, tell me, let me know, as if in that writing, that telling, that knowledge, there is true redemption. The author is looking for a suitable conclusion, for any conclusion, and only his audience can provide it. In continuing the story, in answering this letter, Bosie may yet in writing, in telling his side of the story, create a work of art to stand beside the work of art that is *De Profundis*.

A work of art, Wilde defined in *The Soul of Man Under Socialism*, is 'the unique result of a unique temperament'. *De Profundis* tells a great, terrible story. Its voices range from the most self-pitying to the most self-loathing tones. Its characters develop, regress, stand out in extraordinary light or lie in darkness, casting depraved shadows. Its heart can harden with the violence of its hatred and break with the longing for love reciprocated. It contradicts, celebrates and confounds itself. It is theatrical writing of the highest order. And its author knew its worth. He made one significant change to the text of *De Profundis*. At the letter's beginning he had written, 'an artist as I was'. This he altered to 'an artist as I am'.

THE FIRST AND THE LAST
RENAISSANCE MAN FROM BENGAL

ANITA DESAI

If there are two Indian names I can feel reasonably confident are known in the West, it is those of the poet and Nobel Laureate Rabindranath Tagore and the firm director Satyajit Ray. Both were from Bengal and this is no coincidence. It is more as if, having grown out of common soil, sharing so much in background and upbringing, the one took over where the other had left off so that their common genius continued to grow and produce fruit. They belonged to different generations—Ray's grandfather was a contemporary and a friend of Tagore—but their lives ran along a curiously parallel course and met and mingled at various points along the way.

Tagore has often been called the 'Renaissance Man' since he was a public figure of almost mythical proportions—a poet, painter, novelist, composer and dramatist as well as a political leader, a social reformer and an educationalist, while Ray was sometimes called the 'Last Renaissance Man' since he was not only a film director but a writer and editor of children's stories, a composer and an artist. But these labels sound trite and even arguable—

some have asked, with good reason, '*What* Renaissance?'—until one learns that they refer to the so-called Bengal Renaissance, a powerful movement that began in the last quarter of the nineteenth century and carried over into the early twentieth century.

It was a result of both the Western influences that were so dominant in that heyday of the British empire and, paradoxically, the reaction against them that led to its downfall. Bengal was the first state to come under either influence: it was where the East India Company had first set up its headquarters, transforming a little village on the banks of the Ganges into a great Victorian metropolis of Calcutta, and from there that Clive, Hastings and Cornwallis began to consolidate what grew into an empire. Here, too, the first attempts were made, on the advice of Lord Macauley in his famous 'Minute' of 1835, to convert the traditional, Sanskrit-based and classical Indian education to a modern Western one based on science and the English language. The intention was 'to create a class of person Indian in blood and colour but English in taste, in opinions, in morals and intellect'. His programme had its greatest success in Bengal where many embraced the idea, one going so far as to warble, 'I can speak in English, write in English, think in English and shall be supremely happy when I can dream in English.'

What has not been calculated was the effect of reading the work of Locke, Mill, Hume, Godwin, Rousseau and the romantic poets—the very Indians who were taught to read and appreciate them became fired by the desire for change. Raja Ram Mohun Roy, a scholar who had studied the Hindu scriptures and debated over them with Christian missionaries, founded the Brahmo Samaj, a Hindu movement that sought to restore Indian pride in the old Hindu myths, epics and legends that the British loathed and denigrated, and at the same time to purge Hinduism of such decadent and evil practices as the observance of caste, the burning

of widows, child-marriage and the illiteracy of women. No easy undertaking—on the one hand to glorify the past, on the other to point out its weaknesses and failures. It did, in fact, lead to much confusion and double standards in society, but it also created some men of vision and leadership who took the movement still further into a demand for freedom in the political arena and, in the intellectual, for a literature that was not in the dead language Sanskrit or the élitist court language, Persian, but in the spoken language of the day, simplified and closer to the lives and ways of ordinary people.

The family that contributed the most to these many aspects of the Brahmo Samaj was that of the Tagores, an extraordinarily brilliant, controversial and influential Bengali clan.

Its beginnings were humble. Although Brahmins, they found [II] themselves ostracized in the thirteenth century when an ancestor attended a feast given by a Muslim at which beef was served. So strong was the censorship of the orthodox Brahmin community that the family had to remove itself to a village on the Ganges. Here the fishermen, knowing them to be Brahmins, called them Thakur—a term of respect—which in the nineteenth century was anglicized to Tagore by the British seamen who sailed up the Ganges and whose ships they provisioned. It was the beginning of the family fortune. In the days of the poet's grandfather, the firm of Carr, Tagore & Co. controlled indigo factories, saltpetre, coal, tea, cargo ships, banks and huge agricultural estates, and he was known as Prince Dwarkanath because he lived so lavishly and entertained so royally. When in 1842 he travelled to Europe in his own steamer, for instance, he met both Queen Victoria and King Louis Philippe. At one banquet in Paris he gave a priceless cashmere shawl to each lady present. But his charities were as lavish

as his soirées—he founded the National Library in Calcutta and was the first Indian member and patron of the Royal Asiatic Society of Bengal founded in 1784 by Sir William Jones. He also founded the first medical college, where he himself attended dissections in order to break the taboos against touching and handling the dead. Nor were his interests restricted to science, for he was a leading member of Raja Ram Mohun Roy's social movement, the Brahmo Samaj.

While Raja Ram Mohun Roy died in Bristol, where there is a memorial erected to him, Dwarkanath Tagore died in London in 1846.

His son Debendranath was the spiritual successor of Raja Ram Mohun Roy rather than of his flamboyant and worldly father and earned the title 'The Great Seer'. His father sadly remarked: 'As it is he has very little head for business and now he neglects business altogether; it is nothing but Brahma, Brahma, the whole day!' Yet it was the Prince's extravagance that led to the sudden collapse of the business empire, and Debendranath who not only renounced all claims upon the family trust until all creditors had been paid off, plunging himself and his family into penury, but through judicious management and abstemious living paid off all the debts and even fulfilled his father's promises to various charities. But all this time he longed to withdraw to a secluded place for meditation and travelled in the Himalayas and to remote areas in search of spiritual peace. He did, in fact, build himself a meditation chamber in the village of Bolpur in north Bengal that later became the nucleus of his son Rabindranath's university, Shantiniketan.

Before he acquired such a spiritual reputation, Debendranath had fathered fourteen children, of whom the future Nobel Laureate Rabindranath was the youngest, but who included a dazzling array of musicians, poets, artists and distinguished men.

In that family that had known both great wealth and extreme frugality, excessive self-indulgence and extreme asceticism, Rabindranath had a curious childhood. In *My Reminiscences* he wrote:

Our food had nothing to do with delicacies. A list of our articles of clothing would only invite a modern boy's scorn. On no pretext did we wear socks or shoes till we had passed our tenth year. In the cold weather a second cotton tunic over the first one sufficed.

But, he added:

It never entered our heads to consider ourselves ill-off for that reason. It was only when old Niyamat, the tailor, would forget to put a pocket into one of our tunics that we complained, for no boy has yet been born so poor as not to have the wherewithal to stuff his pockets.

What he did suffer from was the poverty of loneliness, lack of care and an absence of close relationships. In a household swarming with children and grandchildren, the birth of a fourteenth child was no great occasion and he was just one of the pack handed over to the care of the servants while the father followed his demanding pursuits and his mother played cards and performed the religious ceremonies that were thought a proper occupation for a woman of her class and time.

What he did have, in abundance, was the gift of imagination. In his *Reminiscences*, he later wrote:

Looking back at childhood's days the things that recurs most often is the mystery which used to fill both life and world. Something undreamt of was lurking everywhere, and the uppermost question every day was: When, oh! when would we come across it?

He did, when he was twelve years old and his father suddenly invited him along on his travels through the Himalayas. On returning to Calcutta he found his status altered. His mother opened the inner apartments to him and his brothers made him

one of their inner circle. He had already started writing poetry and said: 'Like a young deer which butts here, there and everywhere with its newly sprouting horns, I made myself a nuisance with my budding poetry.'

A nuisance? Not in the Tagore family, so full of gifted and extraordinary young people. His eldest brother was a poet and a mathematician who invented shorthand in Bengali and wrote a manual on it in verse. The second was the first Indian to join the Indian Civil Service, until then manned exclusively by Englishmen, and the first to coax his young wife out of purdah and take her, unveiled, in an open carriage, for a drive through the streets of Calcutta. The third, Jyotirindranath, was one of the most accomplished composers, poets and dramatists of his day.

Between them they wrote plays and performed them, composed music and gave concerts, brought out family magazines and filled them with their essays, poems and short stories. On the anniversary of the founding of the Brahmo Samaj, they formed a choir and sang its hymns. Although Rabindranath never learnt to play an instrument himself, he would sing and pick out tunes on a pianola. He delighted in English tunes like 'Won't you love me, Mollie darling?' and the English game of charades, and would write letters that consisted of delicate pencil sketches and unfathomable riddles.

A newcomer to the family circle, when Rabindranath returned from his travels in the Himalayas with his father, was Jyotirindranath's bride, Kadambari. He wrote in his *Reminiscences*:

And when the new bride, adorned with her necklaces of gold, came into our house, the mystery of the inner apartments deepened. She, who came from outside and yet became one of us, who was unknown and yet our own, attracted me strangely: I burned to make friends.

Of this friendship he wrote nothing in his tantalizingly reticent reminiscences. To learn what kind of relationship it was, we

must turn to a novel called *The Home and the World* in which the hero Nikhil recalls a similar relationship with an older sister-in-law in the days when they were children together:

The Bara Rani came into our house as its bride, when I was six years old. We have played together, through the drowsy afternoons, in a corner of the roof terrace. I have thrown down to her green *amras* [mangoes] from the tree-top, to be made into deliciously indigestible chutnies by slicing them up with mustard, salt and fragrant herbs. It was my part to gather for her all the forbidden things from the store-room to be used in the marriage celebrations of her doll; for, in the penal code of my grandmother, I alone was exempt from punishment. And I used to be appointed her messenger to my brother, whenever she wanted to coax something special out of him, because he could not resist my importunity. I also remember how, when I suffered the rigorous régime of the doctors of those days—who would not allow anything except warm water and sugared cardamom seeds during feverish attacks—my sister-in-law could not bear my privation and used to bring me delicacies on the sly. What a scolding she got one day when she was caught! And then, as we grew up, our mutual joys and sorrows took on deeper tones of intimacy.

As they did in real life when Rabindranath was thirteen years old and his mother died, Kadambari became his surrogate mother and Tagore's biographer writes:

She would make him assist her in household tasks, in cutting betel-nuts or in drying finely cut mango slices which made a delicious preserve. She poured affection on him and yet constantly teased and snubbed him for failings, real or imaginary, so as not to make the precocious boy too conscious of his attainments. When he read her his new compositions, she merely smiled and remarked, how much better other poets had written! ... she checked his conceit from growing [but] sedulously encouraged the best in him, for at that time his most ardent ambition was to win her admiration.

Rabindranath's brother Jyotirindranath was equally attentive to the boy and provided him with a valuable companionship. When he composed music at the piano, the younger brother supplied the songs. When he founded the magazine *Bharati*, the

younger brother filled it with his stories and poems. Kadambari shared their appreciation of literature. Tagore said of her, 'She did not read simply to kill time, but the Bengali books which she read filled her whole mind', and remembered that when the novels of Bankim Chandra Chatterjee were being serialized in the literary journal *Bangadarshan* and a new instalment arrived:

... there was no midday nap for anyone in the neighbourhood. It was my good fortune not to have to snatch for it, for I had the gift of being an acceptable reader. My sister-in-law would rather listen to my reading than read for herself. There were no electric fans then, but as I read I shared the benefits of her hand fan.

The friendship was temporarily interrupted when the young Rabindranath was sent to England to study law. When he returned, he found his brother and sister-in-law living in a riverside villa in Chanderanagore and went to live with them. In ecstasy he wrote:

The Ganges again! Again those ineffable days and nights, languid with joy, sad with longing, attuned to the babbling of the river along the cool shade of the wooded banks. This Bengal sky full of light, this south breeze, this flow of the river, this right royal laziness, this broad leisure, stretching from horizon to horizon and from green earth to blue sky, these were all as food and drink to the hungry and thirsty. ... We would drift along in a boat, my brother Jyotirindra accompanying my singing with his violin. ... Then we would row back to the landing-steps of the villa and seat ourselves on a quilt spread on the terrace facing the river.

This magical villa was known as Moran's Garden, and one can only speculate on the original owner of it. Tagore wrote in his *Reminiscences* of the flight of stone-flagged steps leading to the water from the broad veranda and the sitting-room with its stained-glass windows with coloured pictures, one of which depicted two people sitting on a swing in a garden. He wrote:

Some far-away, long-forgotten revelry seemed to be expressing itself in silent

words of light, the love thrills of the swinging couple making alive with their
eternal story the woodlands of the river-bank.

In 1899 he wrote a short story called 'The Nuisance'.[1] A young
girl Kiranmoyee has been taken by her husband to the riverside
villa to recover from an illness. She is bored and longs for fun. On
the river a boat sinks and a young boy called Nilkanta swims
ashore and finds his way into their garden. She is delighted, finds
him dry clothes, feeds him warm milk and makes him her pet.
She discovers that he belonged to a troupe of itinerant actors and
she has him dress up and act out for her scenes from the dramas
he knows. The others think him a nuisance—he steals mangoes
from the garden, brings in a stray dog, smokes the husband's
hookah on the sly and loses his silk umbrella—but Kiranmoyee
indulges him without seeing the effect this has on the moody sev-
enteen-year-old. Then her brother-in-law arrives from Calcutta
and she turns all her attention to him:

In great gaiety she fed and clothed this brother-in-law who was the same age as
herself. Sometimes she crept up and covered his eyes with hands dipped in ver-
milion, sometimes she wrote 'Monkey' on the back of his shirt, sometimes she
slammed his door and locked him in; he stole her keys, put red chilli in her pan
and stealthily tied the end of her sari to the foot of her bed. They carried on in
this way all day long, chasing each other, laughing.

Left out of it, the boy Nilkanta plots revenge. He is accused of
stealing the husband's inkstand, an elaborate affair of shell boats
and a silver swan, and disappears. Finding it in the trunk he has
left behind, Kiranmoyee throws it into the river before she leaves
for Calcutta. 'Within a day the garden wore a deserted air. Only
Nilkanta's pet dog remained, refusing to eat and running back
and forth along the river-bank, searching for its master and howl-
ing piteously.'

In a novella called *The Broken Nest*, the same light-hearted,
playful romance is charted while the heroine's husband devotes

himself to the press and newspaper, quite unaware of the chang-
ing relationships between his neglected wife and his younger
brother. In *The Broken Nest*, too, the affair comes to an end when
young Amal realizes the true nature of Charulata's feelings; he
withdraws, agrees to an arranged marriage, leaves for England to
study law and Charulata is left behind, broken-hearted, with her
estranged husband.

When it was published in 1901, Tagore's realistic treatment of
a marital triangle was considered scandalous; it came too close to
sexual truths that the Victorian public liked to keep concealed in
the gauzy drapes of historical or mythological fiction. Tagore's
novella was taken as an attack upon that sacred institution, the
Indian family, and the young married woman's sexuality being
aroused by a man other than her husband was thought shocking.
Nor was it the kind of adulterous triangle that at least some of
them might have encountered in Western fiction because the
young man in question was no other than the heroine's *debar*—
younger brother-in-law. It is a relationship that is traditionally
considered a particularly close and affectionate one. The young
bride—so often a child bride—would be in awe of her much older
husband, generally a stranger to her, but in her younger brother-
in-law she could look for a camaraderie to which she would be
accustomed in her own family. Tagore's exposure of the physical
attraction that might underlie such a relationship roused the
shocked disapproval of his Victorian audience.

In 1915 he wrote his even more controversial novel, *The Home
and the World*, which also has a romantic triangle as one of its
themes. The good, well-meaning husband has an unworldly ide-
alism that isolates him from a people mad with excitement over
Gandhi's call to non-co-operation with the British, a return to
swadeshi, and nationalism. His bored, neglected wife comes to life
only when a dynamic young political leader enters the household

and fires her with his zeal for freedom at any cost. The political element dominates in this book, with the husband, Nikhil, providing a mouthpiece for Tagore's own unfashionable faith in restraint, moderation and the development of moral rather than political strength. Bimala provides the romantic note when she falls in love with the young revolutionary, finding in him the spirit of abandon that she misses in her older, more remote husband. It, too, ends in tragedy. The husband goes out to quell riots in the local townplace and meets his doom. Bimala realizes too late the folly of her choice and faces a lifetime of guilt and remorse.

In real life, as well, the end was dramatic and tragic. In 1884, four months after Rabindranath was married in the traditional, arranged way to an illiterate ten-year-old girl, his sister-in-law, Kadambari, committed suicide, probably by taking an overdose of opium. She was twenty-five years old. The police were informed, but her body was not taken to the morgue; instead a coroner's court was set up at the family home, Jorosanko. Its report was destroyed along with a rumoured letter in which Kadambari explained the reasons for her suicide, and all her other letters as well, perhaps to avoid scandal. Her death was not reported in the press. The family account book is said to show an entry: 'Expenses towards suppressing news of her death to the press, fifty-two rupees.' Tagore's biographer Kripalani writes discreetly: 'If the secret was known to any members of the family, it has died with them. In the absence of any authentic evidence, any surmise or guess would be not only be profitless but disrespectful.'

In his equally reticent *Reminiscences*, Tagore does not mention Kadambari's death. Indirectly, he wrote: 'The acquaintance which I made with Death at the age of twenty-four was a permanent one, its blow has continued to add itself to each succeeding bereavement ...'[2] In a letter he describes the years between seventeen and

twenty-three as ones 'of utter disarray'—seventeen is the age of the boy Nilkanta in 'The Nuisance', twenty-three was Rabindranath's age when Kadambari died. He dedicated a poem called 'Broken Heart' to 'H'—his name for her had been Hecate—and she not only appears in 'The Nuisance', *The Broken Nest* and *The Home and The World*, but when he was seventy years old and began to paint, it was her haunting face that he painted over and over again in a series that troubles and disturbs the viewer with its ghostly, wraith-like appearance, sometimes mischievous, sometimes sad, always elusive.

Nearly a century after her death, Satyajit Ray was to bring her back to life again, a beautiful ghost, on the cinema screen.

[III] Satyajit Ray, who had made his reputation with the three films that came to be known as the *Apu Trilogy*, was commissioned in 1961 to make a documentary on the life of Tagore for the centenary of his birth. That year he also made the first of his films to be based on Tagore's work—a group of three short stories that he called *Three Daughters*. They are charming and much-loved. But it was when he took Tagore's controversial novella, *The Broken Nest*, and filmed it as *Charulata*, which is the heroine's name, that he showed how acutely sensitive, sympathetic and complete his understanding was not only of Tagore's artistry but of Tagore's milieu.

How this came about has much to do with the fact that his family belonged to much the same world, cultural and intellectual, as the Tagores. In fact, Tagore knew Ray's grandfather, who composed songs and hymns for the Brahmo Samaj and whose playing and singing was much in demand at Brahmo meetings and social gatherings. They first met at one that was held at the Tagore family mansion, Jorosanko. The friendship carried on into

the second generation—Tagore sat at his son, Sukumar's, bedside when he was dying and sang to him—and the young Satyajit was known for years as 'the grandson of Upendrakishore' and 'the son of Sukumar Ray'.

Like the Tagores, the Rays had a rural beginning. They came from the village of Masna on the banks of the Brahmaputra, which once flooded and divided the family in two, one group known for its wealth and the other for its learning. It also has the same passion for reform as the Tagores. In the 1880s one of them founded a magazine devoted to the cause of women's uplift; this man's second wife was one of the first three women BAs in the British empire—she took her degree only three years after Oxford University's first woman BA—and became a fully qualified physician who trained in Edinburgh. Incidentally, she assisted at Satyajit's birth.

His grandfather, Upendrakishore, a gifted musician, was best known for his re-tellings of Indian folk-tales and the epics, and for founding the printing press, U. Ray and Sons. Being dissatisfied with the illustrations for his books, he set himself up as Calcutta's first high-quality process-engraver and was to win prizes for the quality of his reproductions. The beginnings were humble—he ordered a camera and some half-tone equipment from England which arrived at his house on a bullock cart, but he went on to write learned articles for the *Penrose Annual* [a leading British printing journal]. His grandson Satyajit later wrote of him:

My grandfather was a rare combination of East and West. He played the *pakhwaj* as well as the violin; wrote devotional songs while carrying out research on printing methods; viewed the stars through a telescope from his own roof; wrote old legends and folk-tales anew for children in his inimitably lucid and graceful style and illustrated them in oils, water-colours and pen-and-ink, using truly European techniques.

One can see why Tagore made him his friend.

His son Sukumar went to England to study printing and photographic techniques at the London School of Photo-Engraving and Lithography. He was made a Fellow of the Royal Photographic Society in 1922 and wrote articles for the *Penrose Annual*. He reviewed the first Post-Impressionist exhibition, held by Roger Fry in London, for a Bengali paper. When Tagore was in England, the two met and returned to India together where they founded a Nonsense Club since they shared a love for nonsense verse. Sukumar founded a magazine for children called *Sandesh*— which means both 'sweetmeat' and 'news'—and contributed rhymes to it that are reminiscent of Lear and Carroll but are unique in Bengali literature:

> A duck once met a porcupine; they formed a corporation
> Which called itself a Porcuduck (a beastly conjugation!)
> The lizard with the parrot's head thought: Taking to the chilli
> After years of eating worms is absolutely silly.

These verses are collected in a volume called *Abol Tabol*, later to be translated into English by Satyajit who also continued to edit the magazine *Sandesh*.

Satyajit was two years old when his father died, at the age of thirty five, of the malarial disease *kala-azar*. He and his mother continued to live in the family home behind the printing press and his uncles provided him with role models: one ran the press and made a show of consulting the child over the paper to be ordered for the magazine, another enlarged and tinted photographs and played cricket, while a third kept an hourly diary in a complicated colour code. There were equally colourful great uncles: a cricketer, a perfumer, and a pioneer of the bicycle in India who also made the first phonogram recordings.

But U. Ray and Sons collapsed in 1926, the family home passed into the hands of creditors and Satyajit and his mother went to live with relatives in South Calcutta. It was a house with-

out uncles and granduncles, and his mother went out to work, determined to support herself and her son, so Satyajit was now to experience the kind of loneliness that marked Tagore's childhood—and showed the same stoicism, commenting in his memoirs: 'Adults treat children in such a situation as "poor little children", but that is not how children see themselves.' His solitude allowed him to read and sketch and made him acutely sensitive to light and sound which in turn led to a fascination with the magic lantern and the cinema which was then at the stage when films were called either 'Silents' or 'Partial Talkies' or 'One Hundred Percent Talkies'. He saw films like *Gold Rush* and *Trouble in Paradise*. He was also drawn to Western music. When he was five he was given a pygmyphone on which he cranked out 'Tipperary' and 'The Blue Danube'. At thirteen he discovered Beethoven and started haunting Calcutta's record shops for bargains. A friend remembers that when he found 'Eine kleine nachtmusik', 'he lost his sleep that night.'

A twentieth-century version of Tagore's childhood, one might say, is bourgeois and middle-class instead of aristocratic; but the two did actually meet. As a seven-year-old, Satyajit was taken to Tagore's university in the flat, bare countryside of north Bengal by his mother. They shared a small hut in a grove of trees for a month and on nights of the full moon walked in the ravine where she would sing full-throatedly Tagore's songs and Brahmo hymns. Satyajit had taken with him a small notebook for Tagore to inscribe. The poem Tagore wrote in it, briefly paraphrased, refers to Tagore's voyages all around the world that led him to the highest mountains and the deepest oceans, but ends:

> It seems I never opened my eyes
> Did not spot two steps beyond my door
> Upon a blade of grass, a tiny drop of dew.

Satyajit can be said to have taken this message to heart, later

refusing all offers to make films anywhere but in his native Bengal. Nevertheless, when his mother persuaded him to study at Shantiniketan, he was reluctant. For one thing he was a thoroughly urban young man who loved the city and hated to miss the films he could see there, and for another Shantiniketan had by then acquired a reputation for intellectual sentimentality, effeminate manners and a languid dilettantism. Tagore was still alive and present, but in his eighties and in poor health. More than that, it was his almost god-like reputation that made it impossible for the young student to approach him. Of the three times Satyajit saw Tagore, he said: 'One didn't pay him social calls; one stole up to him with one's heart in one's mouth and touched his feet.' In July 1941 Tagore left for Calcutta, where he died in August, and Satyajit travelled barefoot with the other students for a last glimpse of the poet. In the mêlée that surrounded the occasion, he remembered being pickpocketed.

[IV] It was not the end but the beginning of their wonderful collaboration, which many think achieved its greatest triumph in Satyajit Ray's adaptation for the screen of Tagore's novella *The Broken Nest* in 1964. He was fully aware of the personal dimension to the story, having seen an early manuscript of *The Broken Nest*, with marginalia which refer many times to Hecate and a profile sketch he made of her. Then, having been raised in a family that shared both the Brahmo Samaj ethos and the cultural life of Victorian Bengal, he was acquainted with all the nuances and undercurrents of behaviour in such a household. He was equally intimate with the intellectual life of the period through his father and grandfather who contributed to it along with Tagore.

For instance, the popular Bengali novelist, Bankim Chandra Chatterjee, known as the 'Walter Scott of Bengal', would have had

the same appeal to his family as to Tagore's, and the film is full of references to him. Charulata is shown in the opening sequence as she wanders through the house, taking a volume of his fiction off the bookshelf, riffling through its pages while humming his name. When her young brother-in-law, Amal, arrives in the middle of a rainstorm, he strikes a dramatic pose, theatrically recites a line by Bankim and shouts: 'Have you read Bankim's latest?' Later Bankim is the subject of a conversation between him and his brother, Charu's husband. Bhupati, is more interested in politics and thinks romantic fiction a mere diversion—something he permits his young wife to indulge in but would not lose a night's sleep for himself. Still later, when he suggests to Amal that he go to England to study, Amal gives Bankim as one of the reasons why he feels he must remain in India.

Later Amal and Charu have a conversation that is teasing, alliterative and full of allusions to Victorian Bengal mores. The husband is holding a soirée in an adjoining room to celebrate Gladstone's victory and someone is singing a Brahmo hymn composed by Raja Ram Mohun Roy. Charu has been told that Amal has had an offer of marriage to the daughter of a lawyer in the nearby town of Burdwan who has also offered to pay for Amal's studies in England. While Amal's thoughts revolve around Raja Ram Mohun Roy, who died in Bristol, Charu teases him:

CHARU: First it's off to Burdwan, then Britain, then barrister—
AMAL: Not quite! First Burdwan, then marriage, then Britain, then—
CHARU: Then?
AMAL: Then Bristol. (He laughs.)
CHARU: Then barrister. Then?
AMAL: Then back to Bengal—Black Native, tail between the legs—isn't that so?
CHARU: Bengal? Nothing else?
AMAL: And Bankim—Babu Bankim Chandra (he picks up Bankim's novel, *Bisabriksha*) and *Bisabriksha*.
CHARU: And *bouthan* [sister-in-law]?

Amal reads aloud a line from *Bisabriksha*, subtly altering it to suggest that Charu may be a distracting influence.

CHARU: Is she no good? A bad girl? Shame—?

She stops herself from saying 'shameless'. They look at each other and there is an end to the playfulness. The dialogue does not exist in the novella. But Ray puts together a pastiche of words that suggest all the Victorian nuances of life in a Bengali household at the turn of the century, and adds to it that element of delight in word-games in which both his family and Tagore's were so adept. Ray's dialogue is terse, suggestive and to the point— echoing with uncanny accuracy the point that Tagore had made in the more fulsome, metaphorical way of the Victorians.

In the selection of music for the film, Ray displayed the same intimate knowledge of what would have been played and sung in Tagore's household in the 1880s (the time of his tragic romance with Kadambari). He used two of Tagore's songs—Charu sings one as she sits embroidering her husband's initial (another 'B'), onto a handkerchief in the opening shot. The other is based on a Scottish tune Tagore had heard as a student in England and that Amal sings when he first arrives and is unpacking. Then Charu sings it, more wistfully, as she sits on a swing in the garden (possibly like Moran's Garden) and watches Amal write in a notebook she has bound and embroidered for him. A prose translation of the song will help to convey something of its mood of restless yearning:

> What a sweet breeze blows gently over the flowers!
> For whom do the ripples of the murmuring stream yearn?
> How the groves do echo with the cuckoo's call—
> Cuckoo! Cuckoo! Cuckoo! it sings.
> Whom it is calling, I know not.
> But my whole being calls too.

Finally, there is a song composed by Tagore's brother, Jyotirindranath, that Ray has Amal play on the piano and sing to Charu, bringing to mind the actual triangle.

Ray always took particular pleasure in creating sets that involved period research. There are still Victorian mansions to be found in Calcutta, in dismally dilapidated condition, where props such as the Victorian four-poster bed could be found (although the William Morris wallpaper for Charu's drawing-room had to be specially printed). Setting up Bhupati's printing press would have come easily to Ray, with his memories of the family press. Although Bhupati's had to be of an earlier kind, with his knowledge, as an advertising man, of graphics and design he was able to create Bhupati's paper, (which he called *The Sentinel*), virtually as a facsimile of a Bengali newspaper of Tagore's times. Considering the half-century separating Ray's film from Tagore's novella, it is extraordinary to what extent they dipped into the same material.

There was also the political situation of that day which Ray had to insinuate into the film through a few sure strokes. Bhupati's ardent faith in development through Western political and social concepts is illustrated by the toast he proposes to the victory of the Liberal Party in England, and by his addressing the bewildered young Amal by Disraeli's pet name. In fact, Bhupati is portrayed as 'an archetypal figure of the Bengal Renaissance, a decent dreamer and spinner of half-understood words and ideas, not a doer'. Tagore's portrait of such a figure was not uncritical while Ray portrays him more sympathetically. His portrayal of Charulata as a woman torn between being *Prachina* (conservative, concerned only with family and household) and *Nabina* (i.e. modern, able to read and employ herself with matters other than the household) shows his fascination with a theme he used in many of his films, the conflict being no more resolved in the sixties than it was in Tagore's day.

It was only in the ending that Ray made a distinct departure. Tagore ends his novella enigmatically: Bhupati decided to pack up and leave, to go south and start anew there. Charu faces a bleak future alone in the silent Calcutta mansion. On an impulse, she suddenly says: 'Take me with you.' But when she sees the hesitation on his face, she says abruptly: '*Thak*—let it be.' In the film Ray has them go on a seaside holiday together and shows their hands reaching out to each other and meeting.

When he came to film Tagore's novel, *The Home and the World*, however, his ending was more explicitly tragic than Tagore's which was characteristically enigmatic. Tagore had Bimala look out of the window to see a stretcher being carried towards the house; her husband lies on it, dead or wounded—she does not know. In the film, Ray has Bimala look out of the window dressed in the stark white of an Indian widow's clothing, and there is no doubt regarding Nikhil's death. Ray's biographer, Andrew Robinson, has pointed out that while *Charulata* is

... at root a simple tale of unrequited love, *The Home and the World* is high tragedy: its ambit is of much greater complexity, shorn of easy romance, its characters forced to confront the wider effects of their own deficiencies. The vision is deeper, maturer and darker.

Ray himself said that when he filmed *Charulata*, it was chamber music by Mozart that he had in mind. One can guess that in *The Home and the World*, Mozart was replaced by Beethoven.

Tagore had been torn to pieces by his public for exposing the weaknesses of the Indian traditional family. Half a century on, Ray was criticized equally virulently by that public for deviating from what had become sacrosanct in Bengali literature. Yet no one could accuse him of misunderstanding Tagore.

In 1929 Tagore wrote of the cinema:

The most important element in cinema is the flow of images. The beauty and grace of this moving art form should be fully expressible without the use of

speech ... the flow of images should be awakened and allowed to blossom into an independent source of enjoyment.

Surely that is exactly what Ray has done. He died in April this year [1992]. The wonderful collaboration that was the last bloom of the Bengal Renaissance is over. This lecture is dedicated to his memory.

1 'The Nuisance' has also been translated as 'The Castaway' in Rabindranath Tagore, *Collected Stories* (Madras 1970) [Ed.].
2 Tagore was born on 7 May 1861. This means that he was, in fact, twenty-three when Kadambari died on 19 April 1884, although he was to turn twenty-four less than three weeks later [Ed.].